IMAGES
of America

ELMWOOD
CEMETERY

IMAGES
of America

ELMWOOD
CEMETERY

Kimberly McCollum and Willy Bearden

ARCADIA
PUBLISHING

Published by Arcadia Publishing
Charleston, South Carolina

Printed in the United States of America

Library of Congress Control Number: 2016934144

For all general information, please contact Arcadia Publishing:
Telephone 843-853-2070
Fax 843-853-0044
E-mail sales@arcadiapublishing.com
For customer service and orders:
Toll-Free 1-888-313-2665

Visit us on the Internet at www.arcadiapublishing.com

*This book is for our mothers, Carol and
Virginia, who continue to inspire us.*

CONTENTS

ACKNOWLEDGMENTS

The collection of information and photographs in this book would not have been possible without the work of the following people, all of whom tolerated our requests with grace. We would like to thank Verjeana Hunt, public service supervisor; Gina Cordell, librarian and curator at the Memphis and Shelby County Room; Wayne Dowdy, history department manager at the Memphis Public Library and Information Center; and Sarah Frierson and the staff and volunteers who created Dig Memphis, a digital collection of historical photography available to all people, free of charge; all of your work has been invaluable to this effort. Many thanks to Vincent Clark and Frank Stewart of the Shelby County Archives and Tom Leatherwood, Shelby County register of deeds, for their help preserving and locating photographs and historical documents and for answering questions. We deeply thank Dr. Gerald Chaudron of the Preservation & Special Collections Department/University of Memphis Library and archival assistants Sharon Banker, Charles Griffith, and Christopher Ratliff, all at the University of Memphis Preservation & Special Collections Department. Thanks to Steve Masler of the Pink Palace Family of Museums.

Thanks to Kelly Sowell, Elmwood's historian, for help locating information and photographs, and to staff members Bob Barnett, Leigh Marek, Michael Davis, and Roger Thompson. We thank Charles Shipp, Elmwood Cemetery's board president, for his encouragement. Dale Schaefer and Jody Schmidt provided serious help by proofreading and offering much-needed suggestions.

Many thanks are due to the people who have added so much critical information to the archives at Elmwood over the years, including Frances Crawford Catmur, Sara Holmes, Jorja Frazier, Jody Schmidt, Dale Schaefer, Cookie Swain, Marion Frye, Howard Carothers, Corey Twombly, Linley Schmidt, Richard Williams, Sonny Hanback, Todd Fox, and many others. Elmwood's archives stand in a league of their own compared to other cemeteries, and it is precisely because of the people who cared for them. Thank you.

To Dudley Davis, thank you for the years of encouragement. Thanks to Dyanne and Knight Caldwell for providing comic relief while we worked at the kitchen table night after night. Courtney McCollum, Marlin Mayo, Henry Lovins, Bob and Carol Durdin, Josh and Shana Durdin, Carly and Jack McBride, George Larrimore, Billy and Robin Beaver, "the Ann Arbor gals," Bethany Lewis, Emily Ashby, and Elizabeth Dotson: thanks for letting us talk about this project ad infinitum. To Taylar Dulaney and Caitlin McBride, thank you for helping us get organized. To Pam and Andy Branham, Matt, Maggie, and Savannah Bearden, thank you.

Thank you to Sally Banks, Will Leatherman, Oscar Carr, Irene Brownlow, Mary Carr, Rosalind Withers, and Danielle Smith of the Ernest C. Withers Museum, Emory Cantey Jr., Sharon Pike, Calvin Turley, Shelby County historian Jimmy Ogle, Joelle Pittman, Ken Robinson, Jean Fisher, Bayard and Lisa Snowden, J. Bayard Snowden III, Maggie Catmur Murff and Richard Murff, Lauren Young and the Kemmons Wilson Family Foundation, the Crawford-Howard Private Foundation, Ward Archer, Ples Hampton, Robin Robison, Dr. Dennis Waring, Carol Murff Oates, Tim Sampson, Mary Ann Traylor, Vicky De Haan, Shirley Farnsworth, Gabrielle Beasley, Rogers Beasley, Janet Smith, and Hunter Johnston for their contributions to this work.

Without the works of James Davis, Preston Lauterbach, Dr. Charles Crawford, Dr. Miriam DeCosta-Willis, Dr. Earnestine Jenkins, Lindsey Horn, Douglas Keister, John Cothern, Dr. Douglas Cupples, Green P. Hamilton, Molly Caldwell Crosby, Mimi White, Paul Coppock, Jeanette Keith, Perre Magness, Jerry Potter, Shelby Foote, Wayne Dowdy, Dr. John Harkins, Dr. Beverly Bond, Dr. Janaan Sherman, and many other historians, there would be no history of Memphis. You are the storytellers, and we thank you for your contributions. To Paula Cravens, Susan Clement, Matt

Mathews, Kimberly Richardson, David McCrosky, Gary Shelley, Julie Lester, Shonna Springer, Marshall Hart, Danny Bowers, Ernest Withers, Hooks Brothers Photography, the Mississippi Valley Collection, and the host of photographers and photography archivists who are known and unknown who captured and kept so many moments that have now become our history, there can never be enough thanks. This collection of biographical sketches and photos pales in comparison to their thoughtful contributions to our shared photographed and written story.

We thank Ellen Martin Powell, Olene Carothers, and all of the people who support and keep the tradition of visiting Elmwood and other cemeteries going. Without their commitment and interest, there would be no reason for this book.

Finally, we thank Elmwood Cemetery's board of trustees, supporters, volunteers, families, and friends, all of whom have safeguarded this special place for generations.

Thank you.

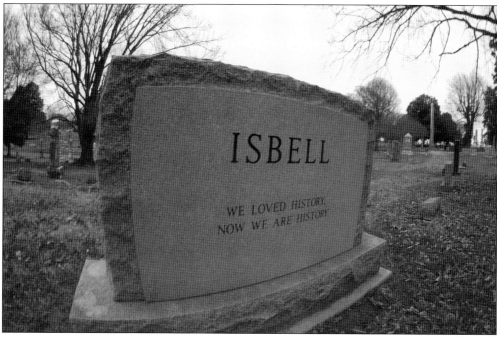

Pictured here is the Isbell family monument at Elmwood. (Photograph by Willy Bearden.)

INTRODUCTION

Some day soon, perhaps in forty years, there will be no one alive who has ever known me. That's when I will be truly dead—when I exist in no one's memory. I thought a lot about how someone very old is the last living individual to have known some person or cluster of people. When that person dies, the whole cluster dies, too, vanishes from the living memory. I wonder who that person will be for me. Whose death will make me truly dead?

—Irvin D. Yalom,
Love's Executioner and Other Tales of Psychotherapy

Throughout history, humans have tried in no small way to cheat death, and short of that, at least to prepare the dead for an afterlife of their particular belief. No matter the pains we take to prepare ourselves for it, death is with us, a companion for life, from the sanctuary of our mother's safe and loving arms to the first admonitions to buckle a seat belt, get a flu shot, learn to swim, or any of the hundreds of fears and warnings each of us hears daily throughout our lives. Death is the overwhelming fear, the great conclusion, the climax of a life lived short or long. As we move through our lives, death becomes more of a reality; we watch as grandparents, friends, and relatives slip away from the earthly plane. We have created the most powerful institutions to explain where it is people go after death. Many of the world's religions seem to speak more about dying than they do of living. It is the great unknown, but it is also the great certainty.

And so the idea of the cemetery being a place for the living and the dead is comforting on many levels. So many modern cemeteries are perfectly coiffed but lack the personality of a beauty like Elmwood. The carriage paths that were so carefully laid out in the mid-1850s are now a bit crumbly, a bit uneven, and in some places, the asphalt that was laid on top has worn away to expose antebellum brick. The headstones, called tablets, thin but wide and about three feet tall, were made of marble and they have expanded and contracted so many times over so many generations that they too have given up the ghost. They splinter and crack at the slightest suggestion, but the staff and some committed volunteers carefully glue them back together so that their stories may be preserved.

Within these 80 acres of rolling hills are almost 1,500 trees, some of which are bigger than any you have seen elsewhere in the state. And some of them are so old that they bear enormous burrs, have been struck by lightning, and support the weight of limbs that dwarf the full-grown trees in our subdivisions. They hollow out over time and die like everything else. But, the people at Elmwood who watch out for and remove the old trees that must come down go to great pains to reclaim some of the wood, and artists and woodworkers have transformed those pieces into tables, bowls, birdhouses, walking canes, and works of art—all so that the story of Elmwood might continue.

There are not just burials at Elmwood. There are stories of individuals who impacted this place we currently inhabit. They had their turn first, leaving us with a compelling and dark, weird and beautiful legacy. It takes all sorts to create a town like Memphis, and Elmwood is a reflection of the city's society. Buried at Elmwood are stories that have been told hundreds of times by now, and we retell some of them in this book. But some will sound unfamiliar to you, and we hope we have done them justice. With this collection of photographs, we focused on a cemetery that since 1852 has seen many triumphs and tragedies of a raucous Mississippi River town. The more than 75,000 souls represented here all have stories—some compelling, some heartbreaking, and some curious—but they will continue to live in our memories as long as we remember and tell their stories.

One

THE FOUNDING
OF ELMWOOD

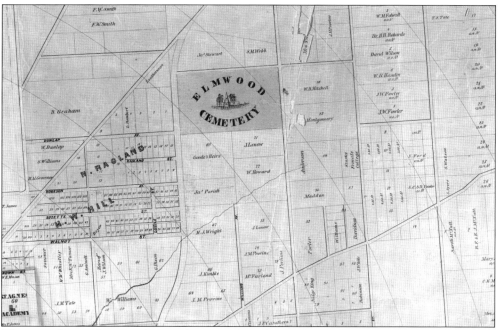

The city of Memphis was chartered in 1819, but Elmwood Cemetery was not established until 1852. Every city needs a cemetery, and Memphis had several before Elmwood. (Courtesy of Shelby County Archives.)

The Morris and Winchester Cemeteries were closed because of neglect, vandalism, and the importance of real estate in the growing downtown area. Most of the people interred there were removed for reburial at Elmwood. Because many of the headstones were relocated as well, a visit to Elmwood reveals markers with dates that precede Elmwood's founding. (Courtesy of American Memory Collection.)

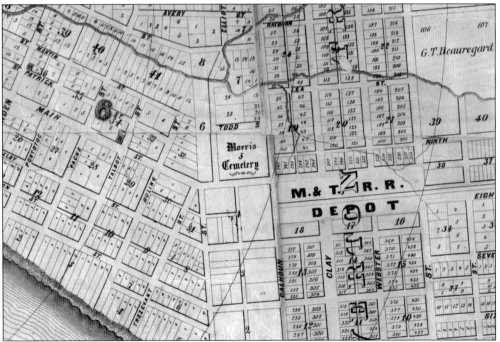

The Morris Cemetery was located on South Main Street across from the Central Train Station, near the site of the Arcade Restaurant. (Courtesy of Shelby County Archives.)

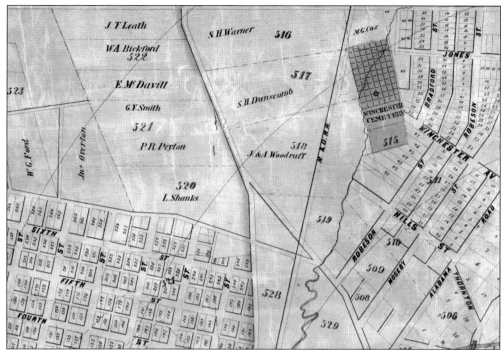

The Winchester Cemetery once encompassed 11 acres and was located near St. Jude Children's Research Hospital. Somewhat famously, the first mayor of Memphis, Marcus Winchester, was buried there, but he was not re-interred at Elmwood; his remains are still in their original burial site. (Courtesy of Shelby County Archives.)

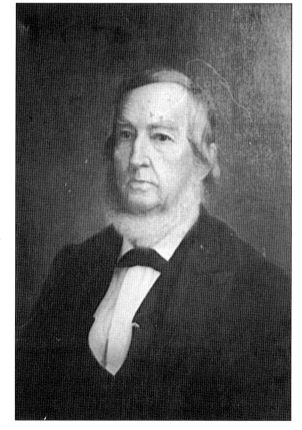

Joseph Lenow was a captain in the Mexican War, and he would use the title for the rest of his life. His obituary read, "Elmwood was his ideal, his goddess, and never did lover pay more loyal tribute to his mistress than Capt. Lenow to his beloved Elmwood. For 31 years he served as the president of the company which owns it, 31 years of faithful, loyal, devoted service that had their fruit in providing Memphis with one of the loveliest spots for the interment that can be found anywhere on the globe." (Courtesy of Elmwood Cemetery Archives.)

11

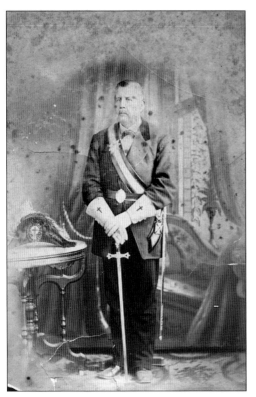

Elmwood was the brainchild of many. The 50 original proprietors of the cemetery chose the name *Elmwood* in a peculiar way. Each wrote a name and dropped it into hat; cofounder Capt. Charles Church drew the slip of paper with the name Elmwood. Elm trees are not native to this area, and had to be ordered in and planted throughout the grounds. (Courtesy of Preservation & Special Collections Department/University Libraries/University of Memphis.)

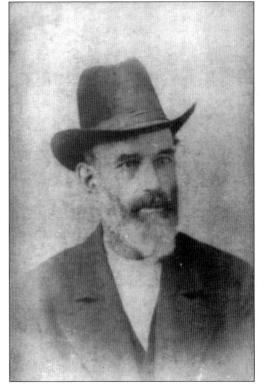

The layout of the grounds, the choice of trees, and the upkeep fell on the shoulders of one person: Elmwood's first superintendent, James Henry Stewart. Born in 1826, Stewart crossed the Atlantic and eventually came to Memphis to accept the superintendent position. Stewart was expected to be on call at all times, except for church and a trip to the bank on Monday. He was compensated $200 annually for his work. (Courtesy of Elmwood Cemetery Archives.)

The first person to be buried at Elmwood was a woman. Born around 1803 in Kentucky, Mary Elizabeth Markham Berry, age 35, married Dr. Reuben Bell Berry. She was his third wife, and upon marriage to Dr. Berry, she became the stepmother of seven. They had one child together. She died in July 1853 and rests with Dr. Berry in the Chapel Hill section of Elmwood. (Photograph by Willy Bearden.)

The Phillips Cottage was constructed as a one-room building set aside for the purpose of conducting business and welcoming those who had traveled the long two and a half miles from the city to visit or conduct business. It is listed in the National Register of Historic Places and is a perfect example of Victorian Gothic carpenter architecture. It was built in 1866, and from 1903 to 1904, a front porch, a vault, and a lovely parlor were added. Critical office space was added in 1998, along with a climate-controlled inner vault. Many pieces of antique furniture were restored and donated to Elmwood by Sally Banks, as well as a hall tree from Sara Roberta Church and the estate of Robert Church, a settee from the Crump family, and a desk from the estate of Gen. A.J. Vaughan. (Courtesy of Elmwood Cemetery Archives.)

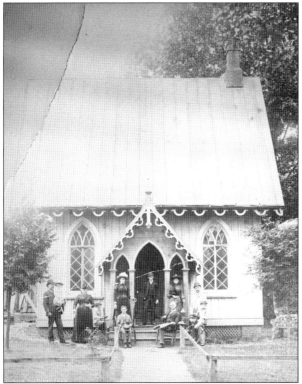

The ringing of the bell is a long-standing tradition at Elmwood, and each time a funeral procession crosses over the iconic bridge, it is rung. The bell was brought to the cemetery in 1885 from the closed State Female College, where it called students to class. (Courtesy of Elmwood Cemetery Archives.)

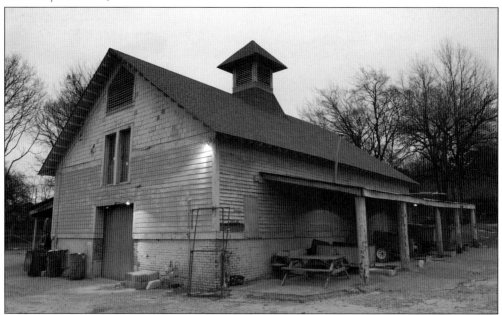

Only one note has been found regarding this structure in the minutes from a board of trustees meeting from June 19, 1901: that the trustees approved a "new stable barn" to the tune of $2,150. The barn now functions as the superintendent's workshop. Next to the barn stands the Caretaker's Cottage, in which an Elmwood staff member lives. The trustees approved a $1,200 expense to construct this building on the west side of the property in March 1900. (Photograph by Willy Bearden.)

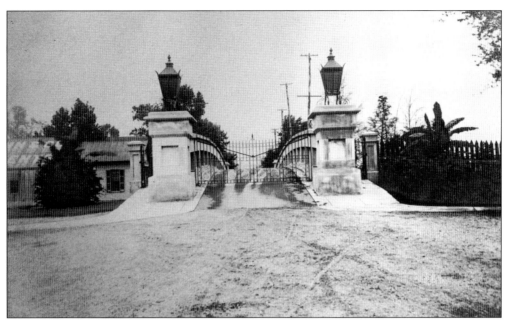

Visitors to Elmwood drive their cars over the bridge and often remark to the staff about how beautiful it is and how it feels as though they have driven back in time. It is the longest span bridge in Memphis, and is listed in the National Register of Historic Places. (Courtesy of Elmwood Cemetery Archives.)

As a small child, Carlisle Page (pictured driving with his son Carlisle) often visited Elmwood Cemetery with his parents. He served on the board of trustees as president for 13 years and was named president emeritus in 1996. Known as "Mr. Elmwood," he greatly expanded the tree collection, bringing the total to over 1,000 trees within 80 acres. Today, the Carlisle S. Page Arboretum contains almost 1,500 trees, one of which is a Tennessee state champion. (Courtesy of Elmwood Cemetery Archives.)

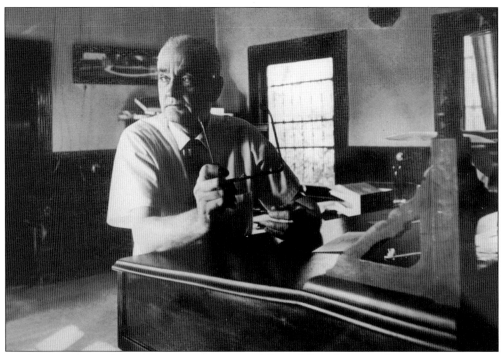

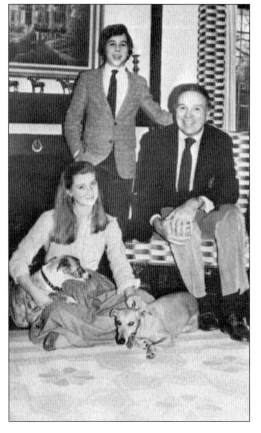

Howard Carothers was the secretary-treasurer for Elmwood for 45 years, from 1936 to 1979, as well as a highly knowledgeable genealogist. He was in charge of the invaluable cemetery books and all record keeping during his tenure. The desk that he is seen leaning on is still in the Cottage. It is 12 feet long and made of walnut, and it came to Elmwood from the Hernando DeSoto Insurance Company. (Courtesy of Elmwood Cemetery Archives.)

Elmwood's greatest benefactor, Hal Bowen Howard Jr., was a native Memphian. A graduate of Yale and Harvard, he was posted in Japan at the end of World War II and went into investment management after his service. His wry sense of humor and distinguished manners made him a favorite of all who knew him. He was a philanthropist who gave generously to organizations that reflected his desire to preserve and maintain Memphis history. At the height of the 2008 financial collapse, he donated $1 million to Elmwood, an amount to be matched in an endowment campaign. He is seen here with his son, Bowen, and daughter, Sara. (Courtesy of the Crawford-Howard Private Foundation.)

Raymond Bryant, born in 1923, was a World War II Navy veteran. He retired from the Tennessee State Highway Department and was a member of Highland Heights Baptist Church. Bryant was supportive of Elmwood's efforts to maintain the cemetery, and he quietly donated to the cemetery each fall in memory of his family. At his death, the cemetery staff was astonished to learn that Bryant had left Elmwood a large estate donation. (Courtesy of Elmwood Cemetery Archives.)

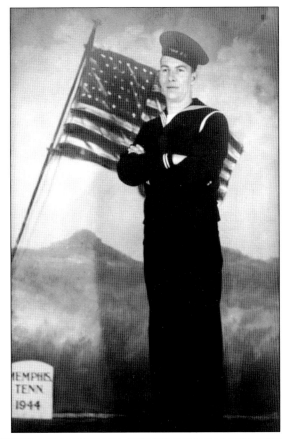

Marion Graves was a schoolteacher for over three decades, a member of Colonial Park United Methodist Church, and a volunteer archivist and genealogist. In her retirement, Graves spent countless hours volunteering at what would become the Memphis & Shelby County Room at the Cossitt Library. It was this spirit of quiet giving that led her to bequeath significant gifts to three Memphis nonprofit organizations, one of which was Elmwood. (Photograph by Willy Bearden.)

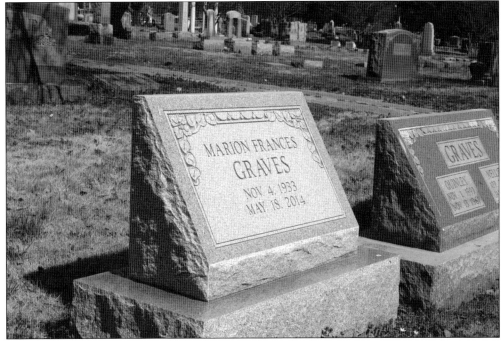

The board of trustees voted in 2015 to design and develop the last five acres of available land within the southwest quadrant of the cemetery, and a portion of this development will be named in memory of Marion Graves, Raymond Bryant, Hal Bowen Howard Jr., and others. (Courtesy of Elmwood Cemetery Archives.)

Two

AMAZING MONUMENTS AND CEMETERY SYMBOLS

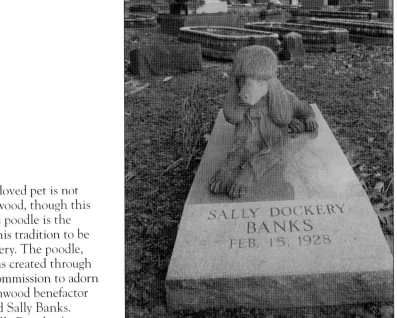

Memorializing a beloved pet is not uncommon at Elmwood, though this statue of a standard poodle is the finest example of this tradition to be found in the cemetery. The poodle, named Bernard, was created through a special, private commission to adorn the gravesite of Elmwood benefactor and longtime friend Sally Banks. (Photograph by Willy Bearden.)

19

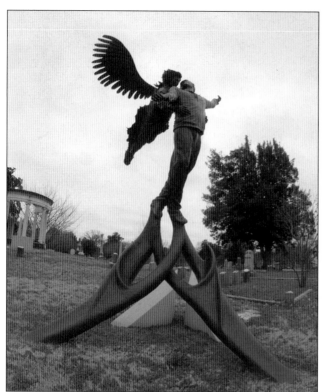

The bronze sculpture to Max Rose on Lenow Circle is the only one at Elmwood to depict an angel in full flight. The entire sculpture stands 13 feet tall. Being lifted into the heavens by the angel is Max, who lost his life in a car accident in 2009. Supporting him are two abstract forms that appear to be releasing or perhaps holding him—or both. (Photograph by Willy Bearden.)

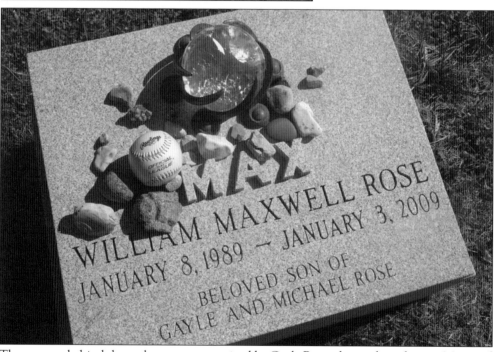

The concept behind the sculpture was conceived by Gayle Rose, the mother of young Max, and expertly designed by Memphis artist Roy Tamboli. It was cast at Lugar Foundry, owned by Larry Lugar. (Photograph by Willy Bearden.)

Only a few feet away from the sculpture for Max Rose are a pair of granite benches, upon which is engraved the poetry of the young man at rest on this lot. (Photograph by Willy Bearden.)

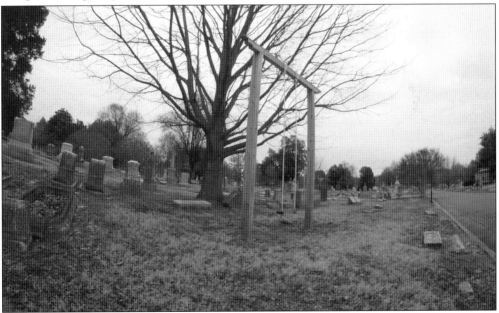

Jeffrey Wellington Smith was an architect and an award-winning toy designer whose son Jeffrey was only five years old when his father died in 1997. The swing at Elmwood was attached to an old champion American holly tree that soon succumbed to age, but friends built a frame for the swing, and so it stands to this day. The staff refers to it simply as "Jeffrey's Swing." (Photograph by Kimberly McCollum.)

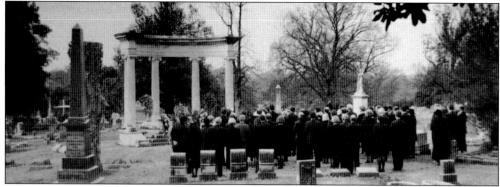

The Grosvenor Arcade is perhaps the most photographed monument at Elmwood. Classical in design, the columns are Ionic. A funeral scene from the 1993 film *The Firm*, based on the best-selling novel by John Grisham, was filmed at the impressive monument. (Courtesy of Elmwood Cemetery Archives.)

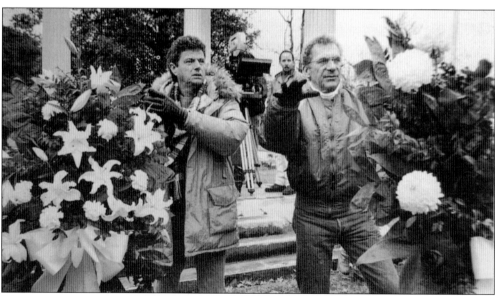

Filming on site required a closed set, so the cemetery was closed to visitors the day of shooting *The Firm*. Pictured here are director Sydney Pollack (right) and cinematographer John Seale in front of the Grosvenor Arcade. (Courtesy of Elmwood Cemetery Archives.)

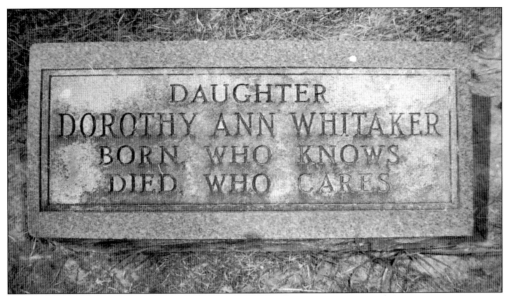

Dorothy Ann Whitaker's simple, humorous marker reflects a casual approach to memorialization. (Photograph by Willy Bearden.)

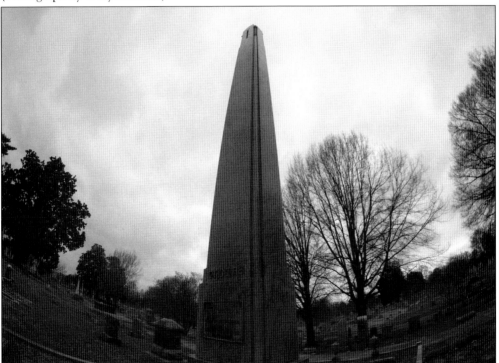

With all the large Gothic and Victorian monuments in Elmwood, the question is frequently asked by visitors, "What is the largest monument in the cemetery?" The answer can be seen soon after crossing the bridge into the cemetery grounds. The 65-foot pink granite obelisk belonging to the family of Rev. Albert Hiram Thomas is an imposing edifice. The monument cost over $27,000 when it was installed in the 1920s. Adjusted for inflation, it has an estimated value of $500,000 today. (Photograph by Willy Bearden.)

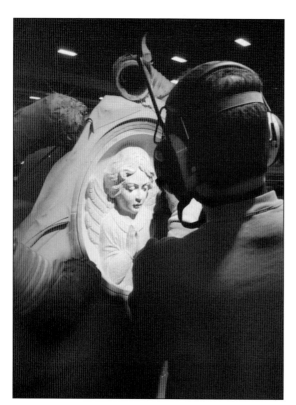

The lot for the victims of the Tennessee Children's Home Society has remained without a memorial of any kind until now. On this lot are buried 19 children who died while in the care of Georgia Tann, the infamous operator of an orphanage that functioned as a black market baby-selling network. Tann is not buried at Elmwood. Children in her care were often allowed to die if they were seriously ill. Pictured here is the monument being carved. (Courtesy of Crone Monument Company.)

Some of the children in her care were adopted by famous parents, like Joan Crawford, June Allyson, and Dick Powell. Funds were raised in 2015 to erect the monument dedicated to the memories of the young lives, inexorably altered. The monument is pictured here as it will appear when finished. (Courtesy of Crone Monument Company.)

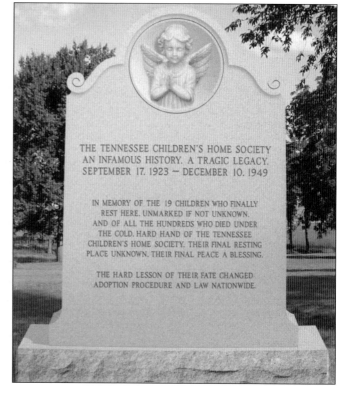

THE TENNESSEE CHILDREN'S HOME SOCIETY
AN INFAMOUS HISTORY. A TRAGIC LEGACY.
SEPTEMBER 17. 1923 — DECEMBER 10. 1949

IN MEMORY OF THE 19 CHILDREN WHO FINALLY
REST HERE, UNMARKED IF NOT UNKNOWN,
AND OF ALL THE HUNDREDS WHO DIED UNDER
THE COLD, HARD HAND OF THE TENNESSEE
CHILDREN'S HOME SOCIETY. THEIR FINAL RESTING
PLACE UNKNOWN, THEIR FINAL PEACE A BLESSING.

THE HARD LESSON OF THEIR FATE CHANGED
ADOPTION PROCEDURE AND LAW NATIONWIDE.

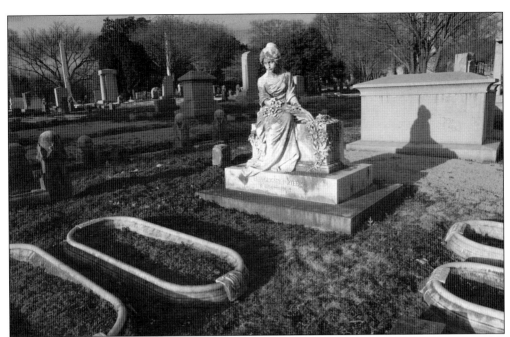

Perhaps the most delicate of the monuments found at Elmwood is the beautiful Carrara marble statue found in the Miller Circle section, erected in memory of Etta Grigsby Partee, who died of Bright's disease, a kidney disorder, on her wedding day. A glass dome once covered the monument, but it broke during a storm in the 1940s. (Photograph by Willy Bearden.)

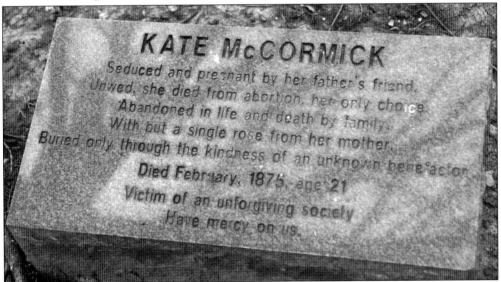

KATE McCORMICK
Seduced and pregnant by her father's friend.
Unwed, she died from abortion, her only choice.
Abandoned in life and death by family.
With but a single rose from her mother.
Buried only through the kindness of an unknown benefactor
Died February, 1876, age 21
Victim of an unforgiving society
Have mercy on us.

The year was 1876. Kate McCormick came to Memphis seeking an (illegal) abortion. She had been seduced by a friend of her father and was desperate. She died from the operation, and her mother was called to claim the young woman. She brought one white rose and left it behind with Kate, saying she wanted nothing more to do with her. The county undertaker buried her at Elmwood. To keep her from being forgotten, benefactors Barry and Marjorie Gerald stepped forward to place a headstone for young Kate more than 100 years after her death. (Photograph by Willy Bearden.)

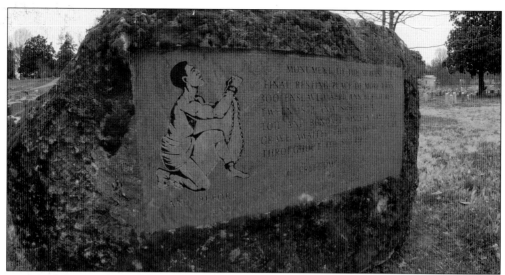

Buried at Elmwood are more than 300 enslaved people of African heritage. The Slave Monument is located on the south side of the cemetery in the midst of a traditionally African American section. The style of the monument suggests an auction block and reminds visitors of the cruel, despicable realities of slavery. (Photograph by Willy Bearden.)

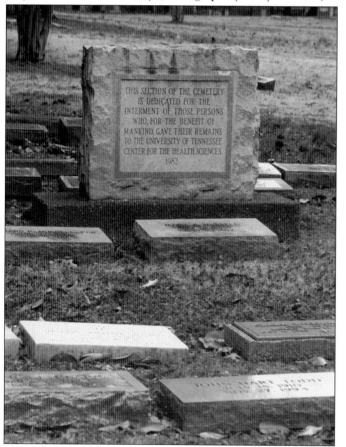

Donors to the University of Tennessee Anatomy and Neurobiology Department don't necessarily give money. This section is reserved for the burial of the cremated remains of the donors who gave their bodies to the university for the purposes of study. The staff refers to this section simply as "UT." (Photograph by Willy Bearden.)

Unique, compelling, and other-worldly—these are only a few of the words that the Falls Monument brings to mind. The statue is bronze and covered in a light green patina. The Falls Monument is not an angel, but a woman who beckons visitors to observe quiet in respect of the dead. (Photograph by Willy Bearden.)

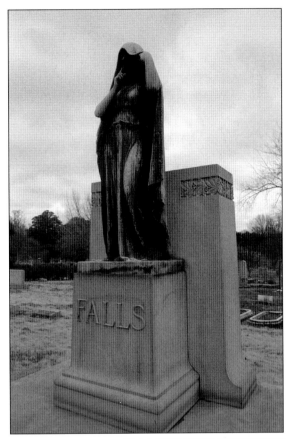

Elmwood Cemetery was founded for use as a public, nonsectarian, and nonexclusive cemetery. From its inception, people from all backgrounds have been buried beneath her ancient trees. This style of monument is found in one of two Greek sections at Elmwood. The Greek community has employed the use of baked porcelain photographs on their monuments, and many of these are still found in their sections. The tradition of using photography in memorial stonework is now used by many. (Photograph by Willy Bearden.)

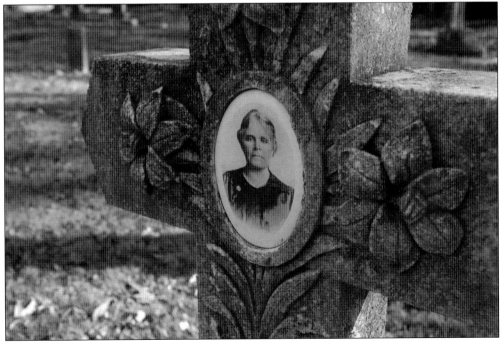

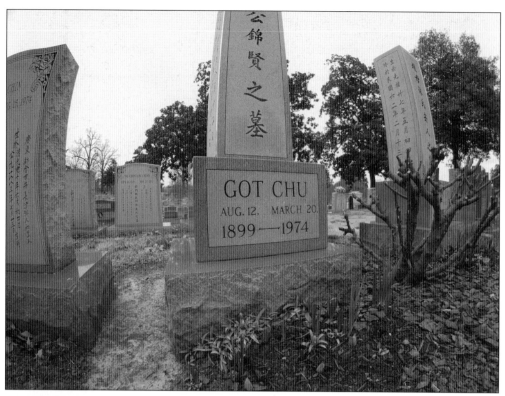

Elmwood is the final resting place for many different groups of people, including Chinese Americans. There are two Chinese sections at Elmwood, and the monuments are elegant standouts bearing Chinese and English characters. (Photograph by Willy Bearden.)

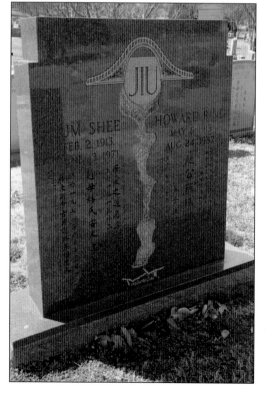

The Jiu Monument depicts the Yangtze River, and upon a closer look, the profiles of the husband and wife who are interred there, Lum Shee and Howard Bing Jiu. (Photograph by Willy Bearden.)

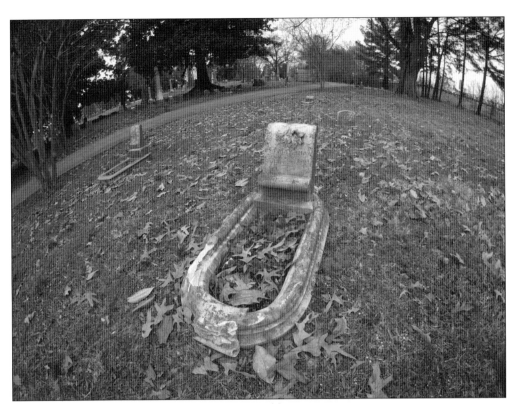

There are several places in Elmwood known as public lots. These are areas where single graves were once purchased instead of large family lots containing many gravesites. One such area is located on the east border of the cemetery and is called Public Lot 3. Over the course of many years, hundreds of children were buried in this section, and many of them had small headstones and monuments. The little monuments sank over time and were forgotten until staff and volunteers discovered them by probing the ground. A collaborative restoration project began, and soon, many stones were uncovered, cleaned, and reset. This monument is one example. (Photograph by Willy Bearden.)

The history of Whyte and Kate Bedford's large round granite sphere, which rests on a pedestal, is forever tied to that of Dr. Peyton Rhodes and George Crone, a monument dealer and one-time president of Elmwood's board of trustees. Dr. Rhodes, a physics professor, was conducting an experiment on the granite sphere by making tiny marks on it to show how much the sun's heat caused the sphere to turn. Crone noticed the minuscule scratches and secured the sphere to the base, and Dr. Rhodes lost the evidence he had spent years accumulating. (Photograph by Paula Cravens.)

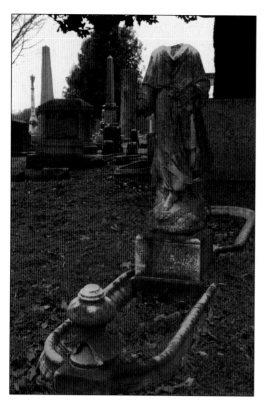

The monument for Sarah Edrington Tate is frequently photographed, and although many suspect the statue's head was knocked off in a fit of vandalism, the truth is that a large tree limb damaged it. Surrounding the statue on the ground is an oblong shape that appears to some to look like a bathtub, but it is correctly known as a Victorian cradle. Cradles can take other shapes, and their size is determined by the age of the deceased. Families who visited these loved ones planted flowers inside to beautify the gravesite. (Photograph by Willy Bearden.)

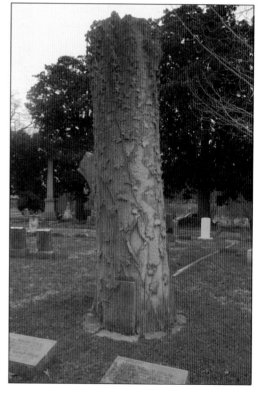

The monument erected for Percy Finlay was purchased on his behalf by his friends. This beloved man's stone depicts a very large tree cut clear across the top, and it is covered in ivy, which symbolizes friendship and endurance. There are several breaks in the bark as well as a broken branch. The sentiment conveyed here is that Finlay was well respected, and that his memory will remain forever; the broken branch symbolizes that someone close to him was lost, and the breaks in the bark represent his endurance. (Photograph by Willy Bearden.)

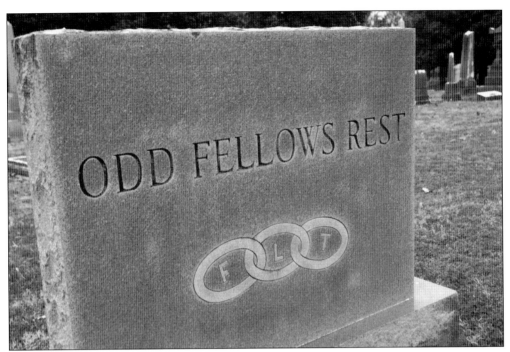

Fraternal organizations have long been represented at Elmwood. The International Order of Oddfellows were common laborers who banded together to form a mutual aid society. This was unheard of in mid-17th century England; the organization's name was an unusually natural fit, given to it by a newspaper reporter in an account he had written about the group. The letters inside the rings stand for friendship, love, and truth. (Photograph by Willy Bearden.)

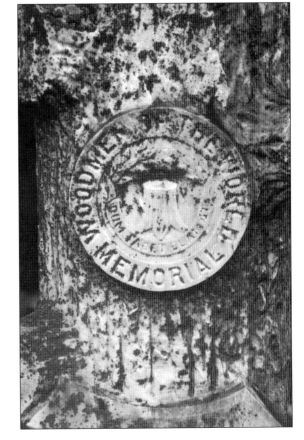

Another fraternal organization, the Woodmen of the World, can be spotted at Elmwood by their tree stump monuments. (Photograph by Willy Bearden.)

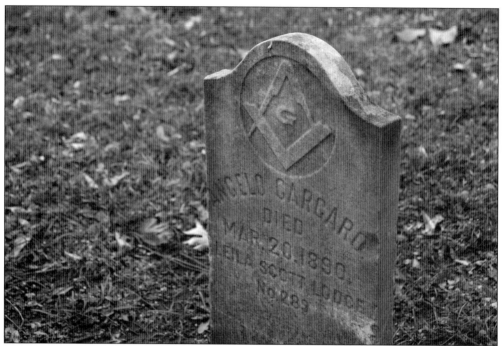

The Masons are well represented at Elmwood by over 900 member-residents representing the DeSoto, Leila Scott, Angerona, and Memphis lodges. (Photograph by Willy Bearden.)

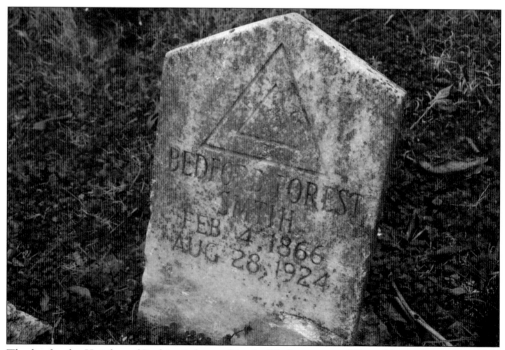

The lot for the Knights of Pythias is located in the Turley section. The tablet-style markers bear an upside-down triangle, the points of which represent friendship, charity, and benevolence. (Photograph by Willy Bearden.)

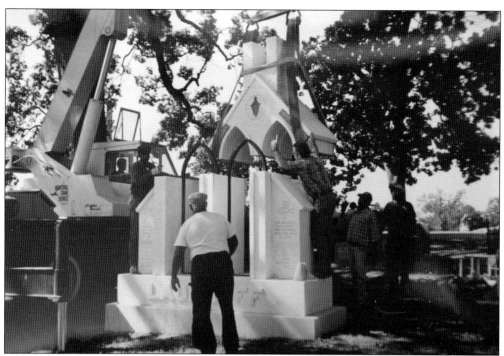

The chapel-shaped Laukhuff Monument found beneath the shade of a magnificent centuries-old oak tree was designed in 1993 by Mickey Laukhuff, the first woman in the United States to own a stained glass company, for her late husband, Ralph. The monument features two stained-glass windows that were made at the company. This photograph shows Elmwood superintendent Sonny Hanback and crew members assisting with the installation of the monument. (Courtesy of Elmwood Cemetery Archives.)

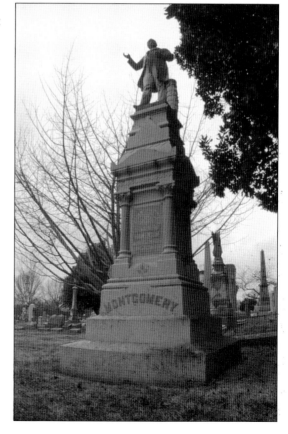

The builder of the first electrical power plant in Memphis was not a municipality, but a laborer who became a wealthy cotton man, Henry Montgomery. He was largely known for founding the New Memphis Jockey Club, a horse-racing track that drew large crowds and was the site of the Tennessee Derby. Montgomery died suddenly as he addressed a crowd in 1887, and his monument depicts him in his last moments alive. (Photograph by Willy Bearden.)

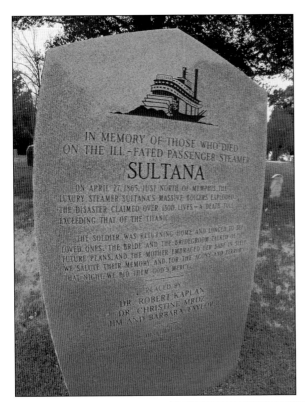

The largest maritime disaster in US history was not the RMS *Titanic*, but the *Sultana*. A steamboat with a faulty, mis-repaired boiler, the *Sultana* traveled against the strong current of the Mississippi River, straining against its weight in April 1865. The *Sultana* carried over 2,500 passengers but was designed for 376. The boiler overheated and exploded just seven miles north of Memphis. Three *Sultana* victims are buried at Elmwood: Esther Spikes, Susan Spikes, and George Slater. The other bodies recovered were Union soldiers who now rest at the National Cemetery on Jackson Avenue. (Photograph by Willy Bearden.)

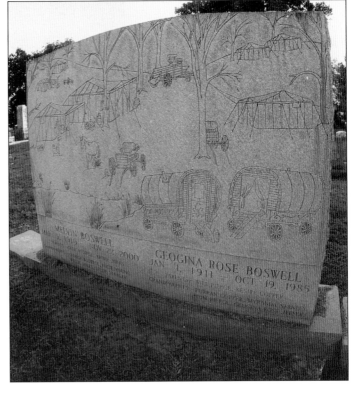

The Boswell family is represented here by a depiction of a traditional encampment in which their ancestors would have lived. The Boswell family is one of several large families of Protestant travelers, or Romani/Romany, who call Elmwood their family cemetery. (Photograph by Willy Bearden.)

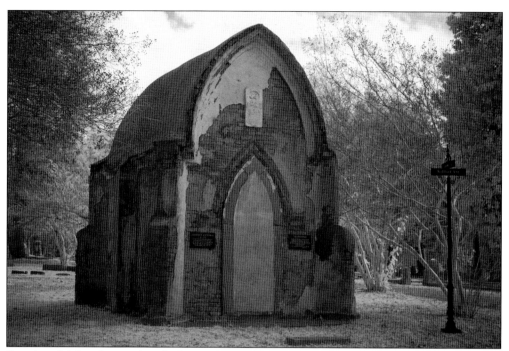

Davidson M. Leatherman's wife, Jane, was originally buried in the Winchester Cemetery and then moved into the Leatherman Mausoleum in 1854 once it was complete. It shows elements of the Gothic style with a peaked doorway that had a marble door at one time and includes a vaulted roof and corner buttresses. There are seven people buried inside of the structure, which is now permanently sealed. (Photograph by Paula Cravens.)

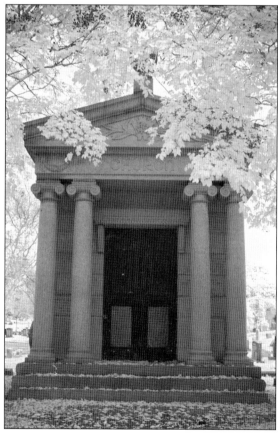

The Church Mausoleum uses Ionic columns, decorative swags, and an urn at the peak of its pediment. The laurel branches in the pediment represent special achievement and distinction. Robert Church Sr. and many of his descendants are interred within the structure, which is full and permanently closed. (Photograph by Paula Cravens.)

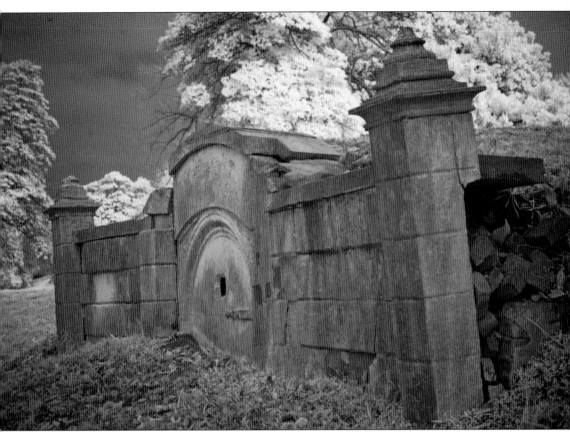

There are three distinctive hillside vaults found at Elmwood for the Shaw, Ayres, and McGehee families; shown here is the Shaw vault. The style is influenced by burial practices dating to ancient Egypt, when graves developed from simple earthen gravesites into more complex structures built half out of the earth, called *mastabas*. The evolution of mastabas into pyramids was due to the increasing need for protection of the *khat*, or mortal body. The size of a pyramid also reflected the social stature of an individual. Hillside vaults were embraced by the Victorians, along with some of the funerary symbolism found throughout Egypt, including urns, obelisks, and scrolls. (Photograph by Paula Cravens.)

Broken columns are found in abundance at Elmwood; they symbolize that a life has come to an end. Ivy represents strength, and sometimes, friendship. (Photograph by Willy Bearden.)

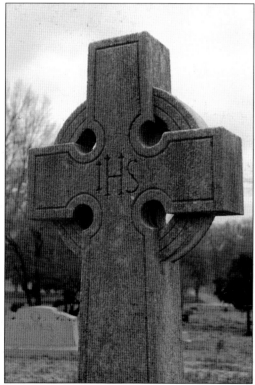

The story of an individual's life, or the values they held dear, are reflected on the stones through symbols. At Elmwood, there are hundreds of crosses, many of which are designed differently but represent the same idea: the Christian faith. Cross variations include the Celtic cross (seen here), the Gothic cross, and more. (Photograph by Willy Bearden.)

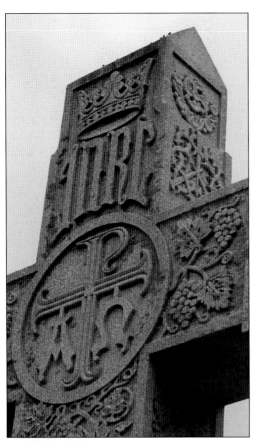

The crown symbolizes the glory of Heaven. Alpha, the first symbol of the Greek alphabet, and Omega, the last, reference the beginning and the end, or the omnipresence of God. Grapes and wheat are symbolic of the body and blood of Christ and are commonly associated with receiving the Eucharist. (Photograph by Willy Bearden.)

There are many flowers found at Elmwood, and the most common are the lily (which represents purity), the wreath of laurel (triumph over death), and roses (a symbol of love). (Photograph by Willy Bearden.)

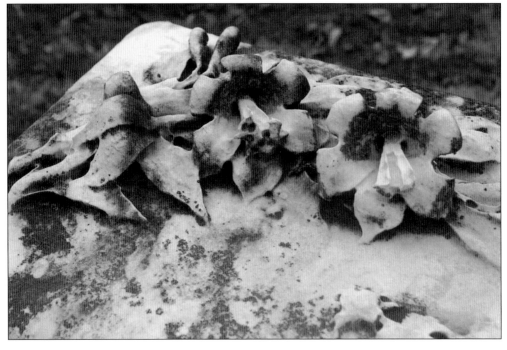

The evergreen symbols of pine, ivy, and fern represent the hope for everlasting life. The break in the bark of the tree suggests an unusually difficult hardship and the perseverance of the spirit. (Photograph by Willy Bearden.)

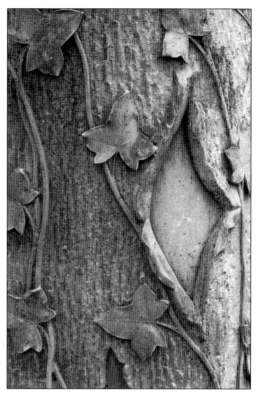

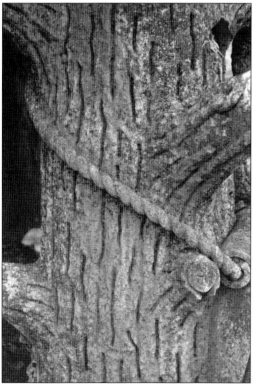

Trees are frequently represented in the statuary as well. They often appear upright, and visitors wonder if they are real trees that have been covered with a concrete mixture. The oak tree symbolizes strength, honor, endurance, and eternity, and is said to have been the tree from which Christ's cross was made. Other symbols include the rope, which represents strength. The branches that are sawn off or broken suggest that a line of the deceased's family tree has ended or that a beloved person was lost. (Photograph by Willy Bearden.)

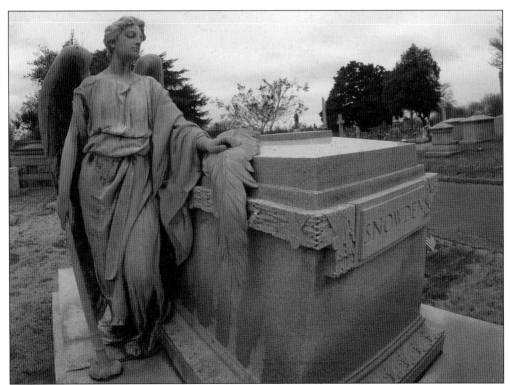

Angels and cherubim are servants of God and the watchers over mankind. Some angels at Elmwood are found to be pointing to the sky, as if to beckon a departed soul to the heavens or to encourage observers to think heavenly thoughts. The Snowden Angel is one of the most famous and photographed statues at Elmwood. She is holding a torch, which is held down with its flame extinguished; this represents that a life has gone out. (Photograph by Willy Bearden.)

Occasionally, lambs adorn the tops of smaller markers. These are frequently for children. The lamb represents Christ as the lamb who was sacrificed for man in exchange for forgiveness of sins. (Photograph by Willy Bearden.)

Doves represent the Holy Spirit. Almost all of the carved doves found at Elmwood are made of marble and are very delicate. (Photograph by Willy Bearden.)

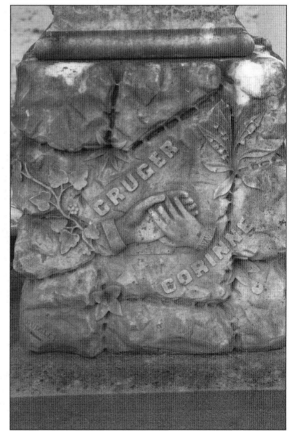

Clasped hands are a complex symbol; they can represent a final farewell, but they might also symbolize marriage or a close bond between people. They can also represent a welcome to heaven. (Photograph by Willy Bearden.)

41

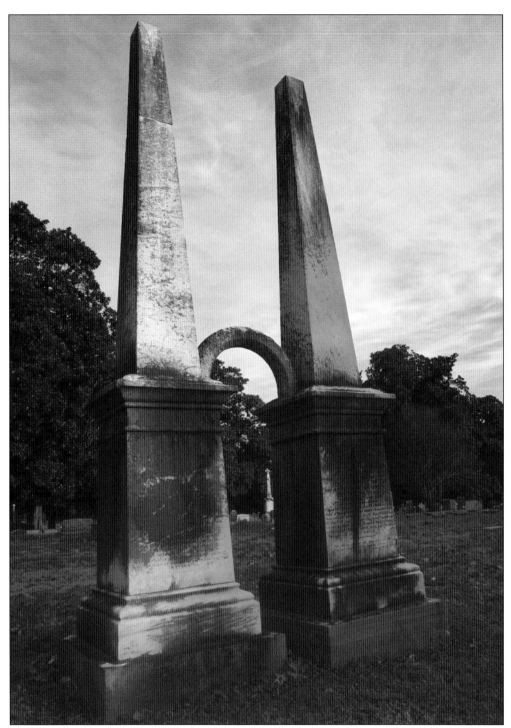

Arches are a passageway into the unknown, a portal through which the soul passes into immortality. The obelisk is abundant at Elmwood and is a symbol of the Egyptian sun god Ra, representing the hope of rebirth and everlasting life. If an obelisk is covered by a cloth, or draped, then the deceased was likely an older person. (Photograph by Willy Bearden.)

Urns are Greek symbols of the body as the vessel of the soul. When they appear draped, like this one, it is assumed that the deceased was an older person. Drapes can also symbolize mourning, respect, and reverence. (Photograph by Willy Bearden.)

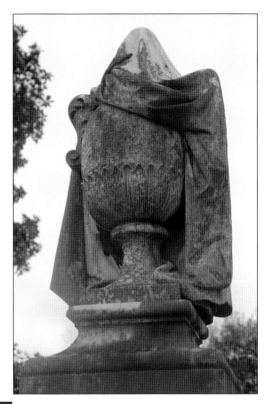

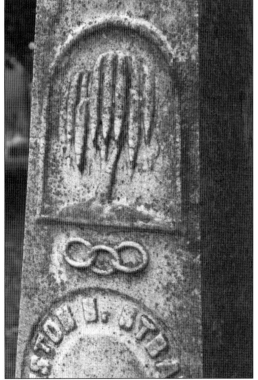

Both urns and weeping willows were early headstone symbols. As attitudes toward death changed, and as people began to think of the dead as though they were eternally at rest, cemetery symbolism became more hopeful, and more centered on the happy reunions that awaited one in heaven. Urns and weeping willows were more stark reminders that death was final. They were less commonly used after the mid 1800s. The chain is symbolic of steadfastness. (Photograph by Willy Bearden.)

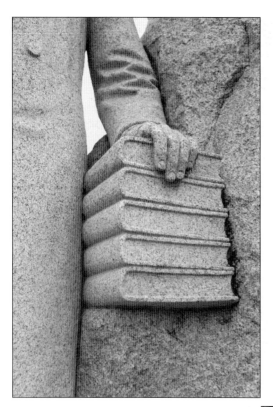

Books suggest a love of learning. This stack of books found on Dr. D.T. Porter's monument illustrates that Dr. Porter was well educated and had passion for knowledge. (Photograph by Willy Bearden.)

The scroll has been used for thousands of years to record written information. Used on a monument, the scroll suggests the passage of time, and that the story of a life has unfolded. The scroll is also symbolic of the Scriptures. (Photograph by Willy Bearden.)

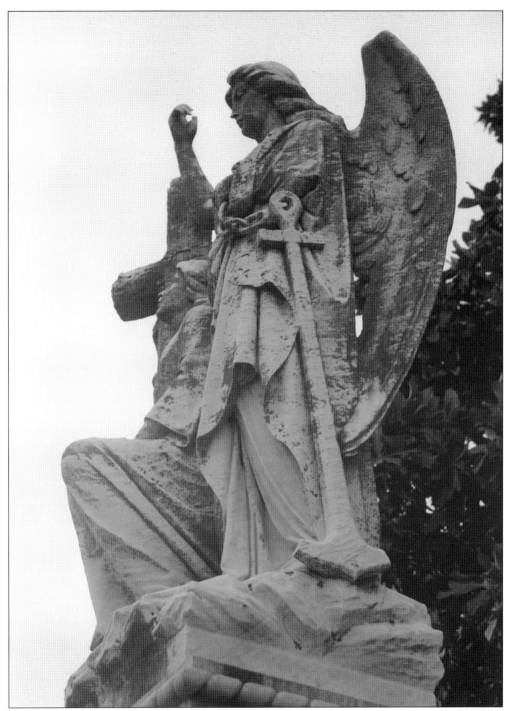

Seen here is a representation of the virtue hope, one of the seven virtues, which include faith, love, prudence, justice, temperance, and courage. Faith and hope are more common in cemeteries. Faith is represented with a chalice and tablets, and hope is depicted as a woman with an anchor. The anchor was also an early Christian symbol: as an upside down cross, it allowed Christians to proclaim their faith in plain view. (Photograph by Willy Bearden.)

A butterfly is a transformative figure, symbolic of the spiritual person's journey through birth, death, and resurrection. (Photograph by Willy Bearden.)

Three

YELLOW FEVER

Yellow fever once ravaged the
American South. Once the disease
gained a foothold and spread across
a city, devastation followed. The
illness respected no boundaries,
and no one knew what caused it. It
was Dr. Walter Reed and a medical
team who would determine the
cause of yellow fever—a bite by an
infected mosquito, in particular,
the *Aedes aegypti*—but that did
not take place until after scores
of deaths. There were three major
waves of the disease, or epidemics,
that steamrolled through Memphis
in 1873, 1878, and 1879. The worst
of those was 1878. (Courtesy of
American Memory Collection.)

In September 1878, more than 200 people were dying every day, and 50 of them were being buried at Elmwood. The daily burial record from 1878, kept in Elmwood's climate-controlled archive, reflects page after page of burials that took place at Elmwood. (Photograph by Willy Bearden.)

The remedies for yellow fever varied wildly throughout the South. One suggested, "If there was much pain in the head, I had him or her cupped until the pain was gone. If there was vomiting when first called I gave a tumbler of strong salt water which emptied the stomach at once and relieved the nausea . . . This is the most effectual cathartic for it seems to neutralize the poison in the blood—the fever usually subsides in 1 night and never returns." (Courtesy of American Memory Collection.)

The lengths to which people would go to alleviate the suffering of yellow fever, or to outrun it, were far. People desperately tried to flee the city when the fever hit, heading upriver to places like St. Louis, and mothers and children were sent off to stay with relatives, if possible. (Courtesy of American Memory Collection.)

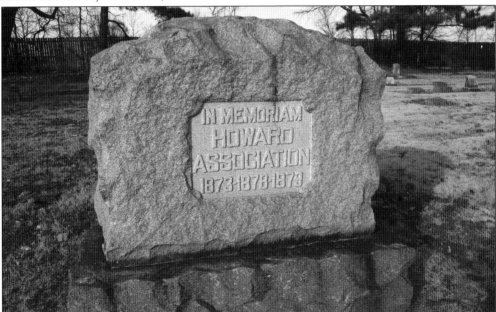

The only course of treatment for yellow fever at the time was simply palliative, but the medical community tried in every way to help. The Howard Association was a benevolent group of doctors who came to Memphis during the epidemics and did what they could. The Howards were often spotted by the yellow armbands they wore and sometimes the cigars they smoked, as smoke was thought to clear away the illness. Many of the Howards gave their lives in the service of others and are buried on the Howard Association lot. (Photograph by Willy Bearden.)

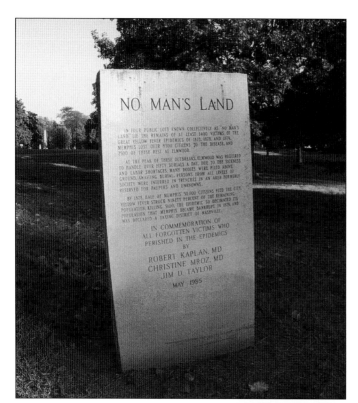

The No Man's Land section of Elmwood is the final resting place for 1,500 victims of the yellow fever epidemics of 1873, 1878, and 1879. Because bodies and caskets often arrived at Elmwood without notice, graves were needed quickly. The gravediggers cut trenches and laid caskets side by side. (Photograph by Willy Bearden.)

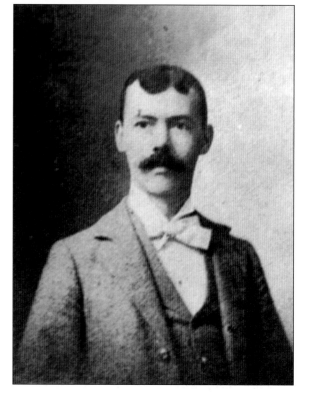

The obituary for Charles Quintard Harris listed his occupation as "retired cashier of the First National Bank." He is credited with keeping open the doors of the bank under great duress. During the yellow fever epidemic of 1878, Harris contracted the disease but showed up for work nonetheless. To this day, the bank awards the most dedicated employees the Charles Q. Harris Leadership Award. (Courtesy of Elmwood Cemetery Archives.)

David Park "Pappy" Hadden is best known for his service to the city of Memphis after the 1878 yellow fever epidemic, for his beloved mule Hulda, whom he rode through the city during his cleanliness inspections, and for inventing the Hadden Horn, a bell-shaped device into which dice were placed for the insurance of a fair gamble. He was president of the taxing district when Memphis lost its charter to yellow fever deaths, and he opened his police court each morning by announcing, "The show is on." (Courtesy of the Digital Archive of the Memphis Public Library & Information Center.)

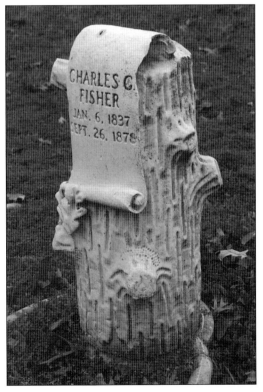

At the outset of the Civil War, Charles Fisher and his brother enlisted in the Confederate army. After the war, he cofounded Gage & Fisher Cotton Factors and served on the city council. When the yellow fever of 1878 hit Memphis, Fisher and several others organized the Citizens Relief Committee, which helped to provide necessities like food and medicine to the people left behind. On September 26, 1878, Fisher died of the fever. He lost his life in service to his neighbors. (Photograph by Willy Bearden.)

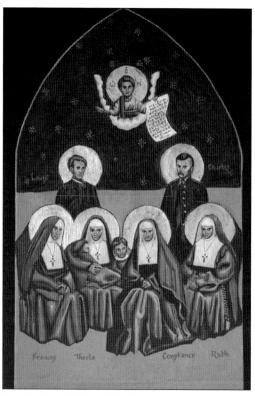

Francis Thecla Constance Ruth.

Sisters Frances, Thecla, Constance, and Ruth are known collectively as the Sisters of St. Mary's, or Constance and Her Companions. Depicted standing behind them are Fathers Parsons and Schuyler. Remembered on September 9 each year on the Episcopal Church's calendar of lesser feasts and fasts, the Sisters of St. Mary's are some of the martyrs who gave their lives during the yellow fever epidemic of 1878. Sister Constance and her companions ran the school and orphanage for St. Mary's. Of the 30 children living in the orphanage run by the sisters, 22 ultimately succumbed to yellow fever. (Courtesy of the St. Mary's Episcopal Cathedral Archives.)

The sisters are buried in the shape of a cross in the Evergreen section of Elmwood. Each year near their feast day, members of St. Mary's Cathedral gather at the gravesites to honor the martyrs. (Courtesy of Elmwood Cemetery Archives.)

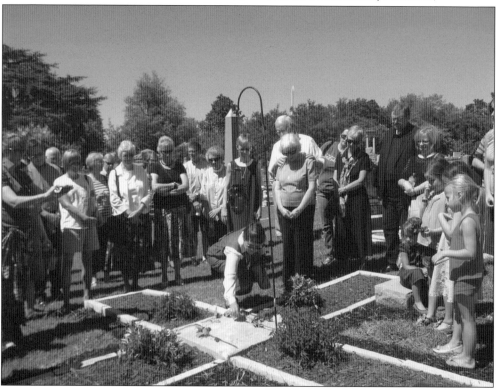

Charles Carroll Parsons graduated from West Point and joined the Union army. In battle at Perryville, he was greatly outnumbered, but he held his ground until alone. He drew his sword and stood at ease although he was surrounded by artillery fire. The Confederate colonel in charge was impressed and let him leave the field. Later, Parsons became rector of Saint Lazarus Church in Memphis. In the 1878 yellow fever epidemic, he worked to help its victims, but he died in September. (Courtesy of the St. Mary's Episcopal Cathedral Archives.)

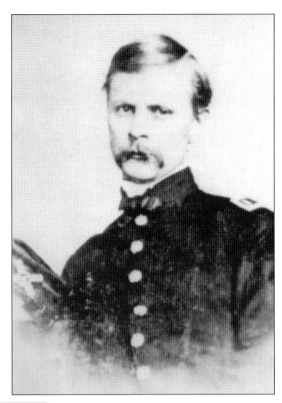

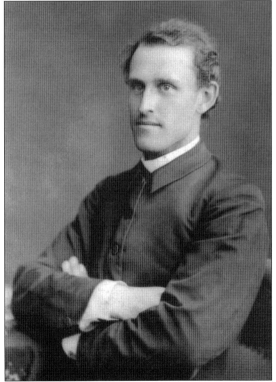

Louis Sandford Schuyler was described early on as a devout child, and this figured into his life's story in Memphis. Reverend Schuyler was in New York when word came that Reverend Charles Parsons was close to death from yellow fever and no Episcopal priest was left to administer the Eucharist in Memphis. He arrived and worked tirelessly for several days but died on September 17, 1878, and is buried next to Reverend Parsons. (Courtesy of the St. Mary's Episcopal Cathedral Archives.)

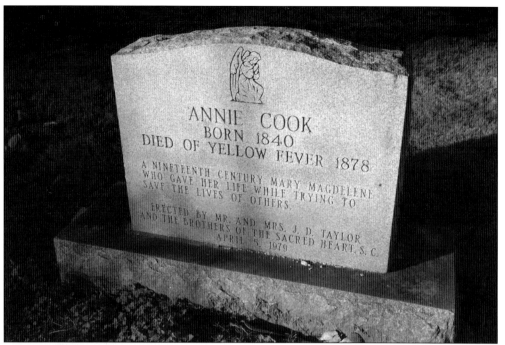

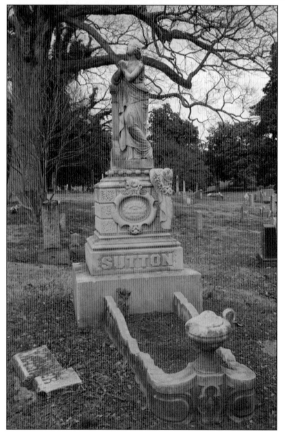

There is no chance that Annie Cook, her true name unknown, could have known the impact she would have on Memphis. She was reportedly of German descent, came to Memphis from Ohio, and opened a brothel. When the 1873 yellow fever hit, she let her "inmates" go and turned her house of ill repute into a hospital. She performed the good deed again in 1878 but died from the fever on September 11. She was instantly known as the "Mary Magdalene of Memphis." (Photograph by Willy Bearden.)

Emily Sutton, also known as Fanny Walker, ran a brothel downtown. When the yellow fever epidemic of 1873 struck the city, Sutton stayed behind to nurse the ill. She caught the fever, died, and was buried in No Man's Land. One of her clients had her moved to a prominent grave space and bought a fine marble statue, but management made sure to install her professional name on gate seals surrounding the space. (Photograph by Willy Bearden.)

Lena Angevine Warner encountered yellow fever first hand as a child when her family was taken by the disease; she survived and considered herself immune. She became the first nursing student to enter the University of Tennessee and was among the first class of nursing graduates, totaling four, in 1889. Warner was a first among firsts: she also became a charter member of the Army Nursing Corps during the Spanish-American War and would later work directly with Dr. Walter Reed in Cuba in the quest to discover the cause of yellow fever. (Courtesy of the Digital Archive of the Memphis Public Library & Information Center.)

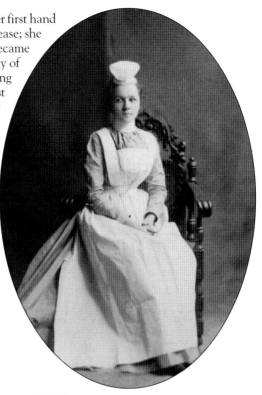

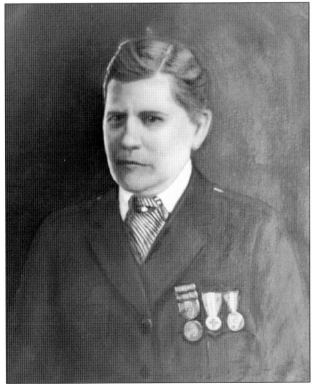

Warner later founded the Tennessee Association of Graduate Nurses. She became the chairman of the licensing board, and her license was No. 000001. She returned to Memphis after her work with Dr. Walter Reed and served as the president of the Tennessee Nurses Association. She was also appointed director of Rural Health and Sanitation for the University of Tennessee Agricultural Extension Service. Warner was saved a space for interment at Arlington National Cemetery but preferred to return to Memphis, and Elmwood, for burial, in 1948. (Courtesy of Preservation & Special Collections Department/University Libraries/ University of Memphis.)

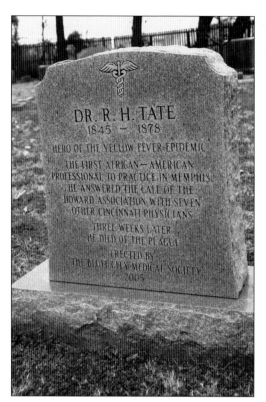

Dr. R.H. Tate's story in Memphis began in 1878. Answering the call of the Howard Association for help fighting the yellow fever in Memphis, Dr. Tate arrived with seven other physicians to help. Dr. Tate was assigned to work in an area of town known as Hell's Half Acre. He was one of the first African-American doctors to practice medicine professionally in Memphis at the time. His grave went unmarked until 2005, when the Bluff City Medical Society donated a monument to his memory. (Photograph by Willy Bearden.)

Mattie Stephenson, heartbroken because her fiancé left her, came to Memphis in 1873 and threw herself into the cause of helping those stricken with yellow fever to recover. She caught yellow fever and died a week later. Stephenson's story deeply moved the citizens of Memphis, and they held a fundraiser to purchase a beautiful monument to her memory. (Courtesy of Norma Johnston.)

William Armstrong, a Confederate veteran, was a doctor who stayed in Memphis to help the sick and dying yellow fever victims in 1873. He sent his wife, Lula, and their children away, and did the same again in 1878 when the fever returned to devastate the city. He succumbed to the fever in late September. The letters he wrote to Lula paint an agonizing picture of the fear and loneliness he experienced in his final days. (Courtesy of the St. Mary's Episcopal Cathedral Archives.)

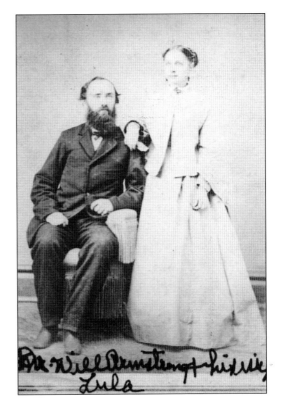

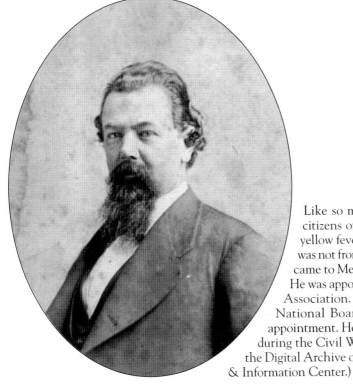

Like so many others who nursed the citizens of Memphis through the 1878 yellow fever, Dr. Robert Wood Mitchell was not from Memphis, but Vicksburg. He came to Memphis to help those suffering. He was appointed president of the Howard Association. He later served on the first National Board of Health, a presidential appointment. He also served the Confederacy during the Civil War as a surgeon. (Courtesy of the Digital Archive of the Memphis Public Library & Information Center.)

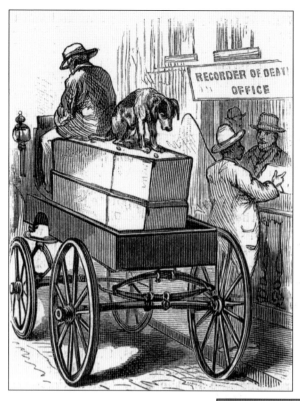

The bodies ravaged by yellow fever were brought to Elmwood by mule-drawn wagon. One of the wagon drivers, Joe Kearney, died in 1983 at an estimated minimum age of 112, although he was thought to be considerably older by one historian. Kearney said that he was given a shot by health officials who told him that it would keep him well for 20 years, but since there was no vaccination for yellow fever at the time, he believed that it was their way of convincing him to take the job. (Courtesy of American Memory Collection.)

As a young physician, Dr. William E. Rogers (pictured) practiced in Brownsville, Tennessee, before serving in the Confederate army. After the Civil War, he practiced in Memphis and was a Howard Association medical director during the 1878 yellow fever. He organized the Memphis Hospital Medical College, and one of his sons, Dr. William Boddie Rogers, also served as its dean. Dr. William Boddie Rogers Beasley, a descendant, practiced in remote parts of Africa and Appalachia, was trained as a surgeon, and even won a Fulbright fellowship. All three men rest at Elmwood. (Courtesy of William Boddie Rogers Beasley.)

Four

DYNASTIES, MUSIC, AND LEGENDS

Napoleon Hill came to Bolivar as a young man and fell in love, but he had no money, and so he joined the California Gold Rush and opened a successful trading post. He returned to Memphis and, with $10,000, married Mary Woods, whose parents gave the couple $25,000 to start their lives. Hill is remembered for his business prowess and for building a home recognized as a gaudy yet fine example of robber-baron Victorian. (Courtesy of the Digital Archive of the Memphis Public Library & Information Center.)

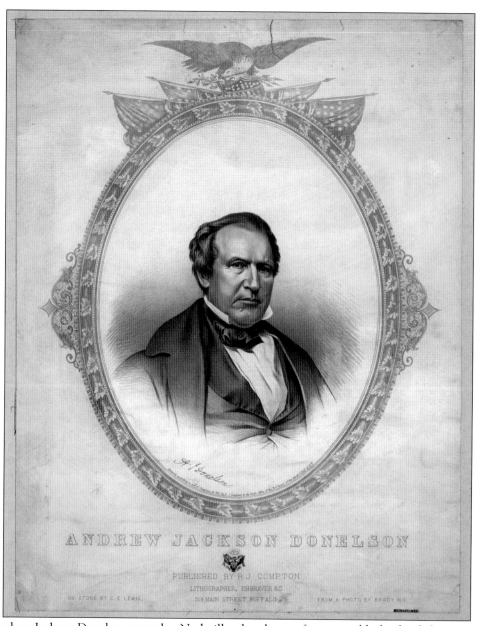

ANDREW JACKSON DONELSON

PUBLISHED BY R J COMPTON
LITHOGRAPHER, ENGRAVER &C
208 MAIN STREET BUFFALO

ON STONE BY C E LEWIS

FROM A PHOTO BY BRADY N.Y

Andrew Jackson Donelson moved to Nashville when he was five years old after his father passed away. He moved to the Hermitage, home of his aunt Rachel and her husband, Andrew Jackson, who treated him as their adoptive son. Donelson graduated from the US Military Academy at West Point in 1820 and spent the next two years as aide-de-camp to Andrew Jackson during the Indian wars. He assisted Jackson in the presidential campaigns of 1824 and 1828 and became the president's private secretary for his two terms in the White House. Donelson continued his service in government for the next 20 years, serving as head of the US mission to the Republic of Texas, minister to Prussia in James K. Polk's administration, and as former president Millard Fillmore's vice presidential running mate in the 1856 election. Donelson moved to Memphis in 1858 and divided his time between the city and his plantation holdings in the Mississippi Delta. He died in 1871. (Courtesy of American Memory Collection.)

The lovely lady in this portrait is Anne Overton Brinkley. Memphians know she is the woman for whom Annesdale, an Italianate villa, was named. Built in 1850 by Dr. Samuel Mansfield, the mansion was purchased by Anne's father, Robert Campbell Brinkley, in 1869 and given to Anne and her husband, Robert Bogardus Snowden, as a wedding gift. The mansion still stands. It is privately owned by Ken Robison and offered for special events. (Courtesy of Ken Robison.)

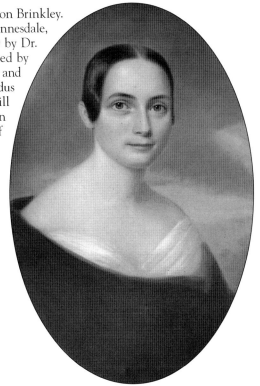

Memphians know very well the legacy of John Overton, a grandson of one of the original proprietors of Memphis. Overton, once believed to be one of the wealthiest men in the state of Tennessee, was a banker, businessman, and member of the state house and senate. Overton Park and Overton High School are named for him and his family. The park contains over 300 acres in the heart of the city, and within its borders are the Memphis Zoo, the Brooks Museum of Art, and the Memphis College of Art. (Courtesy of Lisa Overton Snowden.)

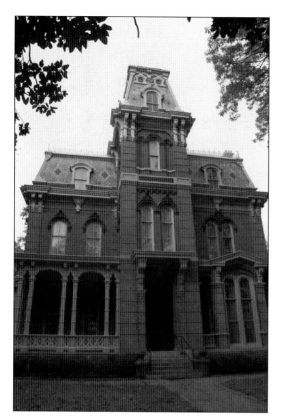

Amos Woodruff came to Memphis in 1845 and quickly grew a profitable carriage-making business. He built an awe-inspiring mansion in what is now known as Victorian Village. His daughter Mollie, who lived in the mansion, lost two children at birth and one husband to pneumonia. Many believe that Mollie haunts the mansion, mourning her losses there. (Photograph by Willy Bearden.)

Originally from Copenhagen, Denmark, C.K. Holst came to the United States via Boston in 1829. He learned the cabinet-making trade in his own country and became a well-known undertaker in Memphis who made it his mission to see *Hamlet* every time it was offered locally. If something went wrong during the course of his work, his standard response would be "There's something rotten in Denmark." (Courtesy of Canale Funeral Directors.)

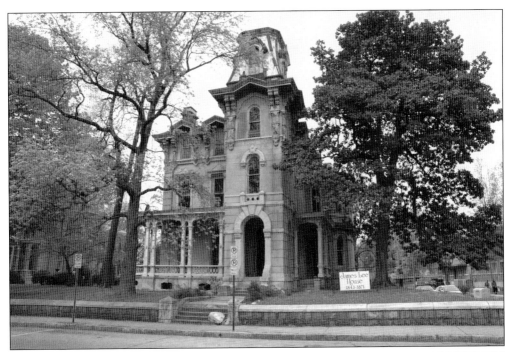

A visit to Victorian Village in downtown Memphis will reveal the work of Edward C. Jones and Mathias H. Baldwin. Out of the firm of Jones and Baldwin came the original Peabody Hotel (lost to fire), First Baptist Beale Street, the D.T. Porter Building, and Clayborn Temple, the site of Martin Luther King's "I've Been to the Mountaintop" speech. The firm also designed the Woodruff Fontaine House. Another design, the Goyer-Lee House (pictured), is still standing in Victorian Village and was recently turned into a bed and breakfast. (Courtesy of the Digital Archive of the Memphis Public Library & Information Center.)

Gen. Geril Colton Greene, a Confederate brigadier general, was perhaps the man behind the mask—the Mardi Gras mask, that is. In 1874, he suggested a large-scale party thrown at a time when even farmers could attend. The Memphis Mardi Gras was born, and several of the secret societies created in 1875 remain today. (Courtesy of Elmwood Cemetery Archives.)

A modernist architect who helped to change the landscape of downtown Memphis, Jack Tucker's first project, the Timpani Building, transformed a former cotton warehouse into condominiums and office space. Tucker helped to transform Mud Island, Charlie Vergos's Rendezvous, and the Memphis Convention & Visitors Bureau, to name only a few. Tucker designed the Lord's Chapel at Elmwood, and his ashes are interred in the Stokes Columbarium just outside the building on the east. (Courtesy of Elmwood Cemetery Archives.)

James Davis was a Memphis historian who wrote articles under the name "Old Times" from 1869 to 1873, and out of these came a collection in book form. The book is remembered as a colorful series of narratives, less an accurate historical accounting, of events taking place in the early days of Memphis. It is still treasured as a collection of early Memphis memorabilia. (Courtesy of the Digital Archive of the Memphis Public Library & Information Center.)

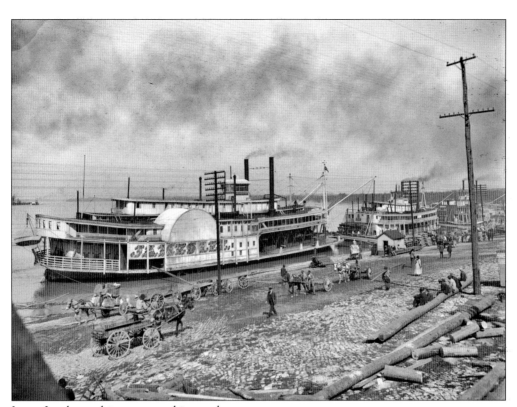

James Lee began his career working on boats owned by others, but his natural business acumen made him successful. He eventually owned a steamboat line that specialized in bringing cotton to the Memphis markets from the Mississippi Delta and returning with supplies for the stores to sell to locals. This business venture lead to more steamboats, all of which were named for his children. The Lee family lot at Elmwood is uniquely shaped in the form of a triangle. Lee died in 1889, but he lived with his son, an attorney, who alternately worked as a banker and businessman. He eventually joined his father's company. (Courtesy of American Memory Collection.)

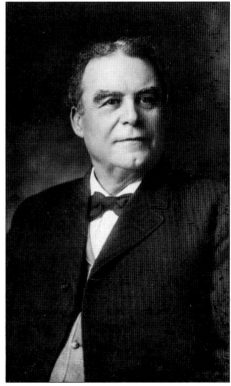

Evidence of Robert Galloway's life and his sense of civic duty can still be found today in Midtown Memphis. He used his wealth to build a beautiful 12,000-square-foot mansion called Paisley Hall in the Evergreen neighborhood. Galloway was one of the founders of the Memphis Park Commission, and was responsible for acquiring the land at Overton and Riverside Parks. (Courtesy of the Digital Archive of the Memphis Public Library & Information Center.)

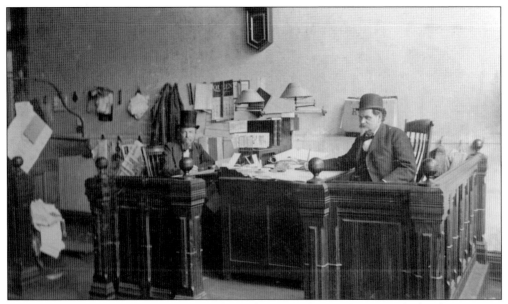

Stephen Cummings Toof (right), a printer by trade, was in charge of printing the local newspaper, the *Memphis Daily Appeal*, during the Civil War. The paper was pro-Confederate, and in order to avoid being shut down by Union troops, he loaded the press onto a train, and in cahoots with owners John Reid McClanhan and Benjamin and Caroline Dill, they kept the paper on the move all over the South and in production for the duration of the war. (Courtesy of Elmwood Cemetery Archives.)

One of the founders of what is simply known today as Porter-Leath, Sarah Murphy Leath's husband died when her two children were young. Because of this experience, she was receptive many years later to contributing to the new Protestant Widows' and Orphans' Asylum. She donated property and funds to the organization, which memorialized her by renaming the organization the Leath Orphan Asylum. It would later become known as Porter-Leath after an additional bequest was made to the organization in memory of another Elmwood resident, Dr. D.T. Porter. Leath died in 1857. (Courtesy of Elmwood Cemetery Archives.)

Represented leaning slightly upon a cane with a mis-buttoned vest, rumpled attire, untied shoelaces, and one hand behind his back, Wade Hampton Bolton ran a cotton and slave trading firm downtown with three other men, one of whom would fatally wound him in a pistol duel in 1869. His likeness is perfectly captured in this eclectic statue, which it is said caused his wife to faint upon her seeing it for the first time. (Photograph by Willy Bearden.)

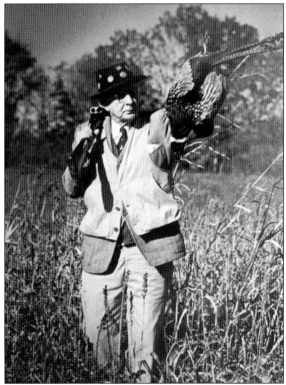

Nash Buckingham was a true sportsman, winning the Southern Amateur Athletic Union heavyweight boxing championship in 1910. Buckingham enjoyed hunting and fishing, and would become a great writer on outdoor life and one of the organizers of the Outdoor Writers Association of America. He wrote nine books on fishing, shooting, and outdoors activities. His beloved and famous 12-gauge HE Grade Super Fox shotgun, "Bo Whoop," was thought to be lost for many years, but was found in 2006 and offered at auction. The gun was purchased by Elmwood benefactor Hal B. Howard Jr. and remains on display at Ducks Unlimited in Memphis. (Courtesy of the Digital Archive of the Memphis Public Library & Information Center.)

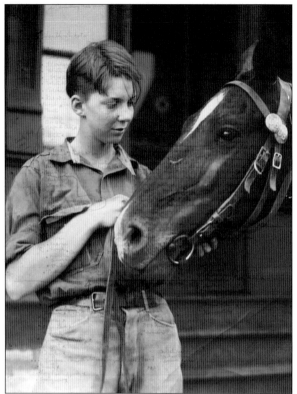

Evelyn Estes left her hometown in June 1927 and traveled for nine months by horseback from Tennessee to California. She was armed with a shotgun and joined by a dog, Kip. She was nicknamed "Calamity Jane's Little Sister" and rode her horse across the United States at a time when there were no highways. She completed the journey once more in 1940. (Courtesy of Debora Gordon.)

Berry Brooks was a cotton factor, world traveler, conservationist, big game hunter, photographer, and naturalist. He gave lectures throughout the United States, showing films of his African safaris, adventures in southeast Asia, and big game hunts in Alaska. For many years, his animal trophies in the Pink Palace Museum's Berry B. Brooks African Hall were the favorite of visitors. (Courtesy of Elmwood Cemetery Archives.)

Barbara Jo Walker was a student at Memphis State University when she won the title of Miss Memphis. She went on to win the title of Miss America in 1947 and was the last Miss America to be crowned in a swimsuit. (Courtesy of Preservation & Special Collections Department/University Libraries/University of Memphis.)

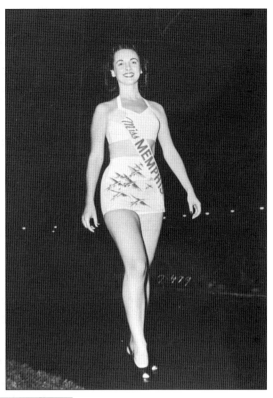

Barbara Jo Walker received many offers from Hollywood but came home to Memphis to finish her college education. She married Dr. John V. Hummel and raised a family. Pop music fans will note that her son Andy was a founder of the seminal Memphis band Big Star, along with Alex Chilton. (Courtesy of Preservation & Special Collections Department/University Libraries/ University of Memphis.)

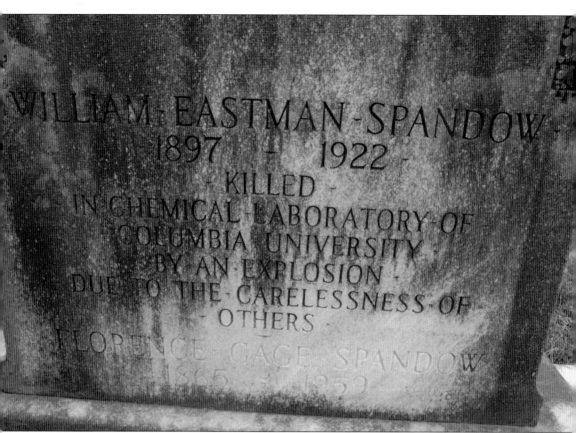

One of the most curious monuments in Elmwood is the marble memorial to William Eastman Spandow, a 25-year-old Memphian who was killed in a tragic accident in a chemical laboratory in Havemeyer Hall on the campus of Columbia University in New York City in 1922. Spandow's mother had his monument inscribed as such. The subsequent investigation showed that Spandow was in fact the author of his own accidental demise. (Photograph by Willy Bearden.)

Born in Chambers County, Alabama, in 1838, Jasper Newton Smith had two sisters who would figure into his widely publicized disappearance. When he went missing, Smith's estate was worth about $100,000; today, he would have been worth millions. He left home one evening with a satchel of gold, went to meet friends at a saloon in Whiskey Chute, a popular area for gambling, and never came back. His body was never recovered. The lion in front of his statue guards his memory. (Photograph by Willy Bearden.)

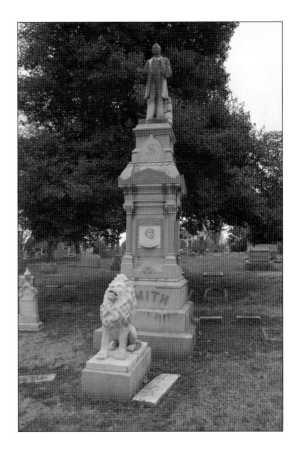

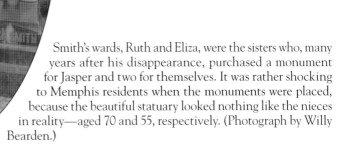

Smith's wards, Ruth and Eliza, were the sisters who, many years after his disappearance, purchased a monument for Jasper and two for themselves. It was rather shocking to Memphis residents when the monuments were placed, because the beautiful statuary looked nothing like the nieces in reality—aged 70 and 55, respectively. (Photograph by Willy Bearden.)

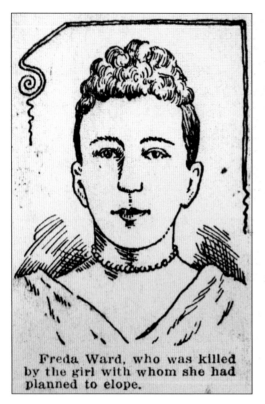

Freda Ward, who was killed by the girl with whom she had planned to elope.

On January 25, 1892, Freda Ward (pictured here) and Alice Mitchell planned to run away together, but their "unnatural relationship" was discovered, and instead of being torn apart, Mitchell met Ward on the cobblestones where Ward was boarding a ship up the river to St. Louis—and there slit Ward's throat. (Courtesy of the Digital Archive of the Memphis Public Library & Information Center.)

The court case that followed was widely covered in national newspapers. It was the first time the word *lesbian* was used in commercial print. Mitchell was sentenced to a mental institution in Bolivar, Tennessee, where she died. (Courtesy of the Digital Archive of the Memphis Public Library & Information Center.)

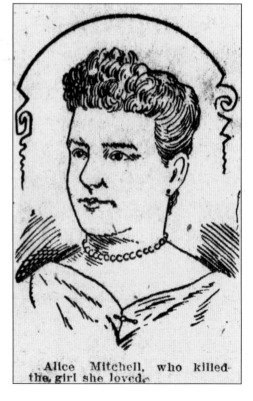

Alice Mitchell, who killed the girl she loved.

As a young man, Daniel Webster "Kit" Dalton ran away and joined Gen. Nathan Bedford Forrest's cavalry during the Civil War, but fell in with a band of guerrillas led by William Quantrill. He later joined the James Gang and began robbing banks and trains. Governors of several states offered a reward of $50,000 for Dalton, dead or alive. When caught years later in Kentucky, he was pardoned on the promise that he would live the life of a law-abiding citizen. (Courtesy of canteymyerscollection.com)

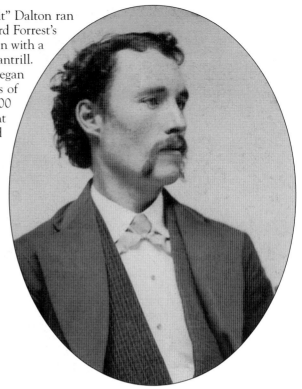

Known around town as "Vance Avenue Alma," Alma Theede was married seven times in her life to six different men and was accused of killing three of them: Roy Calvert, whom she killed in self-defense; Michael McClavy, a wealthy contractor whom Alma had murdered because she had grown bored with him; and Ed Gill, husband No. 5, a deaf lumberman who was shot in the back of the head on a country road. (Courtesy of Preservation & Special Collections Department/University Libraries/University of Memphis.)

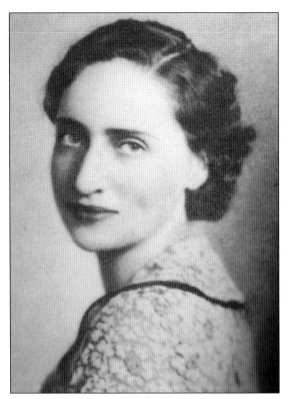

The first wife of the notorious Prohibition-era gangster George "Machine Gun Kelly" Barnes, Geneva Barnes Ramsey Williams rests at Elmwood. After a tumultuous six-year marriage, Williams filed for divorce and remarried, while Machine Gun Kelly reinvented his life with his second wife, Kathryn Thorne. Kelly was eventually sent to Alcatraz, but Williams remarried and lived until she was 96 in Los Angeles. Machine Gun Kelly is buried in Texas. (Courtesy of the Ramsey family.)

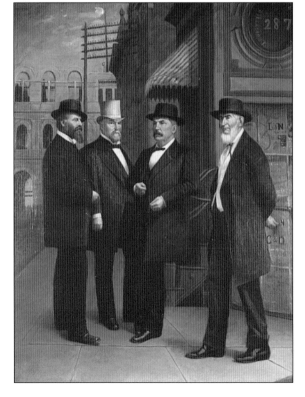

One of Elmwood's groundskeepers was leaving work for the day and was halted by the sight of four men who he said were dressed "old-fashioned." As he approached the men, they disappeared. After telling his story to others, it was determined that the men he saw were the ghosts of the "Four Men on a Corner," a painting by Charles Pinkney Stewart. All of the men in the painting are buried at Elmwood: Pappy Hadden, Napoleon Hill, Henry Montgomery, and Archibald Wright. (Courtesy of the Woodruff Fontaine House Museum.)

Robert Berryman was the operator of a nightclub called the Silver Slipper in the 1920s. He served a short stint in prison on a gambling charge—a hint of things to come. He is seen here with one of his employees. (Courtesy of Preservation & Special Collections Department/University Libraries/University of Memphis.)

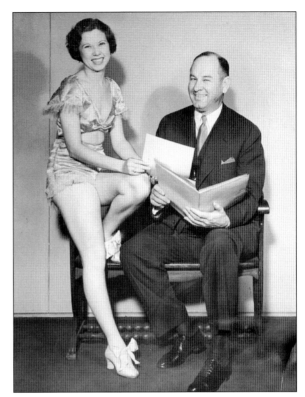

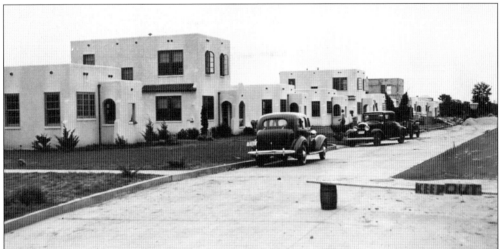

Berryman later opened Berryman's Tourist Court in 1937, a lovely tourist camp offering amenities to travelers in the days before Holiday Inn. The business began to attract a seedy clientele, including bank robbers. However, Berryman's life sentence for killing John Phillips by shotgun interrupted his business management. Berryman claimed self-defense, but 40 witnesses to the murder said that a gambling feud was the cause. While in prison, Berryman was somehow allowed to leave to visit relatives. The prison warden resigned after an investigation, but Gov. Jim McCord commuted Berryman's sentence because of his ill health. Berryman later bought an interest in the Parkview Motel & Restaurant, now an assisted living community at the edge of Overton Park. (Courtesy of Preservation & Special Collections Department/University Libraries/University of Memphis.)

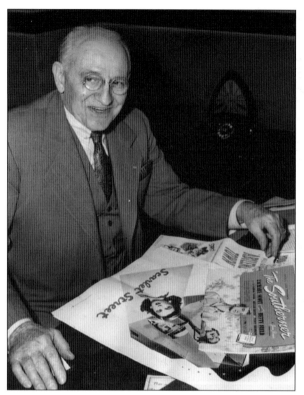

Few people wielded more power over the morals of the citizens of Memphis than Chairman of the Memphis Board of Censors Lloyd Tilghman Binford. From 1928 until 1956, Binford used his scissors to protect locals from any film that promoted mixing of the races, any film starring Charlie Chaplin, films deemed to be "immoral" in any way, and any film depicting a train robbery. (Courtesy of the Tennessee State Library & Archives.)

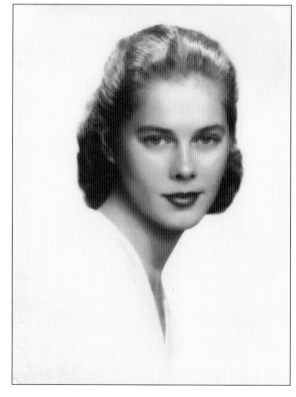

Carroll Seabrook Leatherman worked her adult life in many charity organizations, and even founded the first sobriety center exclusively for women in Memphis. She wrote two books, *The Old Man and the Dog* and *Goodbye Ole Miss*, the latter of which recounted her life in the rural South, the economic and social changes she witnessed over time, and how they affected the Mississippi Delta. The book was a bestseller and is available online. (Courtesy of Leatherman family archives.)

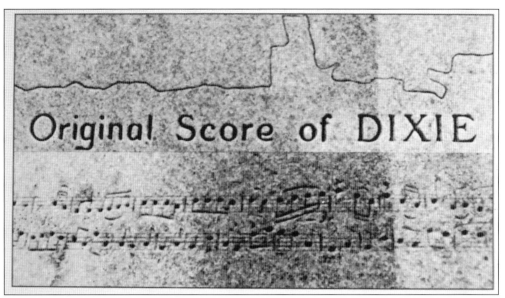

Herman Arnold is widely given credit for writing "Dixie," which he orchestrated and played at Jefferson Davis's 1861 inauguration. Professor Arnold, who wrote the notes of the tune on the wall of a theater in Montgomery, Alabama, where he was conducting an orchestra, said he first heard the tune being played by minstrel Dan Emmett, who could not transcribe music. Arnold's wife, Victoria, was a second cousin of Napoleon Bonaparte. (Photograph by Willy Bearden.)

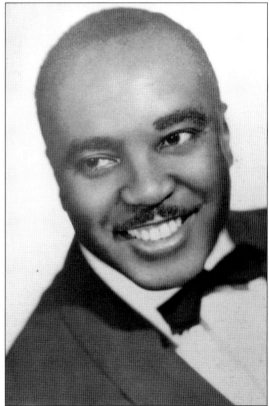

Jimmie Lunceford came to Memphis after graduating from Fisk University to teach music and coach football. He assembled and conducted a band of students, the Chickasaw Syncopators, which toured the United States and played extensively at the Cotton Club. The band was lauded as equal, if not superior, to Count Basie's Orchestra. Lunceford died very suddenly of a heart attack at a personal appearance in Oregon while on tour in 1947. (Courtesy of the Digital Archive of the Memphis Public Library & Information Center.)

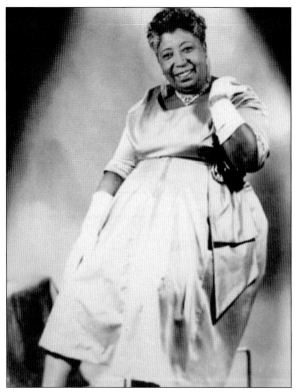

At the age of 13, Lillie Mae Glover ran away from her Nashville, Tennessee, home to begin a life as a blues singer. Glover performed in minstrel shows across the South but settled in Memphis in the late 1920s. She took the stage name Ma Rainey II after the iconic Ma Rainey passed away. (Courtesy of Elmwood Cemetery Archives.)

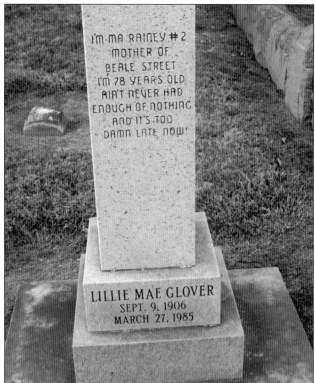

I'M MA RAINEY # 2
MOTHER OF
BEALE STREET
I'M 78 YEARS OLD
AIN'T NEVER HAD
ENOUGH OF NOTHING
AND IT'S TOO
DAMN LATE NOW!

LILLIE MAE GLOVER
SEPT. 9, 1906
MARCH 27, 1985

Ma Rainey II was known as the "Mother of Beale Street," and even into her waning years, she packed the house at Blues Alley. Her monument speaks volumes about her sense of humor. (Photograph by Willy Bearden.)

Sid Selvidge is best known as a singer/ songwriter who married folk music and the blues of the Mississippi Delta. He was a disc jockey on WDDT AM radio in his hometown of Greenville, Mississippi, where he spun rock 'n roll and jazz records. As a college student, he played music at Memphis folk clubs and met bluesman Furry Lewis. He helped form seminal Memphis band Mudboy and the Neutrons and was founding executive producer of the internationally syndicated radio show *Beale Street Caravan*. (Photograph by Steve Roberts.)

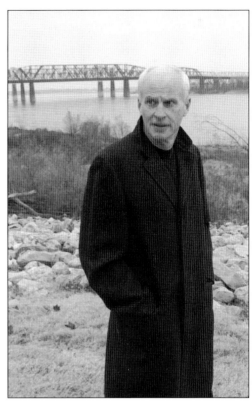

John Hampton was a Grammy Award– winning producer, engineer, and musician who worked magic for over 30 years at famed Memphis studio Ardent Recording. Among his best known productions are *Family Style* by Stevie Ray and Jimmie Vaughn, *New Miserable Experience* by the Gin Blossoms, and The White Stripes' *Get Behind Me Satan*. During his career, Hampton racked up over 20 gold and platinum records, many Grammy nominations, and three wins. (Courtesy of Ples Hampton.)

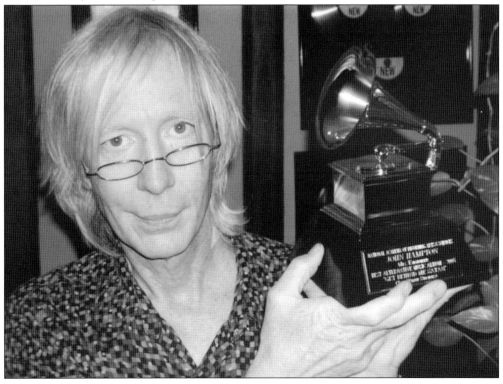

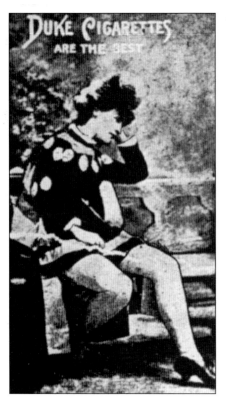

Marie Greenwood Worden was discovered in 1881 while vacationing with her family. Gifted with a voice for opera, Worden studied under Louisa Cappiani in New York. During her career, Worden performed at the New York Grand Opera House, the Metropolitan Opera House, and throughout the major cities of the United States. (Courtesy of Elmwood Cemetery Archives.)

Marie Greenwood Worden performed with a series of opera companies, including her own, and finally returned to Memphis to open her own music studio. She became known as the premier vocal teacher in the mid-South. (Courtesy of Elmwood Cemetery Archives.)

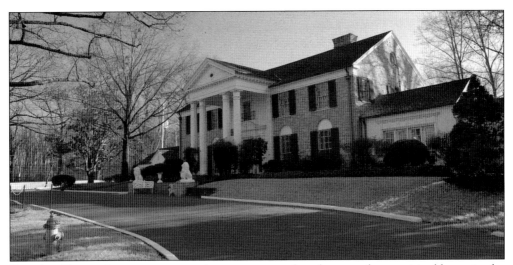

Buried at Elmwood are two women who are connected to the second most visited home in the United States. The land on which Elvis Presley's eventual home was built was given to Grace Toof in 1881 as a wedding gift from her father and was named "Graceland" for her. After her death, Toof's nephews sold the property. Many years later, Mary Jenkins Langston took a job at Graceland in 1963 and worked for Elvis for 14 years. She perfected the peanut butter and banana sandwich, frying them in two sticks of butter for every three sandwiches. Elvis thought of Langston as a family member and bought her four cars and a three-bedroom house before his death. (Photograph by Willy Bearden.)

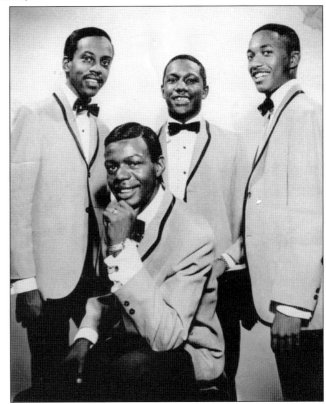

From left to right, high school friends Julius Green, John Gary Williams (seated), Robert Phillips, and William Brown formed a band and, after a rowdy recording session, a Stax Records employee suggested a new name: the Mad Lads. Only Green is buried at Elmwood. The band recorded several songs of note, including "Don't Have To Shop Around," "I Want Someone," and "I Want A Girl." The songs were all recorded on the Volt label, a subsidiary of Stax Records. (Courtesy of Preservation & Special Collections Department/ University Libraries/ University of Memphis.)

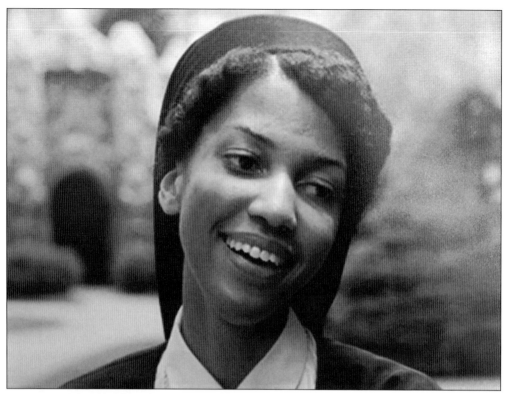

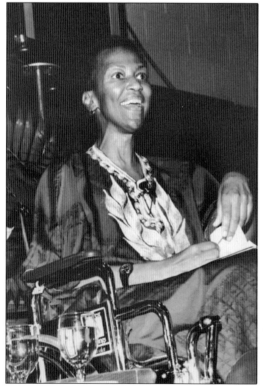

Born in Yazoo City, Mississippi, in 1937, Bertha Bowman was raised in a Methodist home, but because of her early education in a school run by nuns, she converted to Catholicism at the age of nine and later became a nun known as Sister Thea. She taught at schools and universities in Wisconsin, Mississippi, and Louisiana. In 1987, she became instrumental in the publication of a groundbreaking Catholic hymnal that was devoted to the inclusion of African American Catholics. (Courtesy of Elmwood Cemetery Archives.)

Sister Thea was also known as a poet and singer, and her albums can be found in libraries and other collections. She was profiled by Mike Wallace on 60 Minutes. She was posthumously awarded the oldest and most prestigious award given to American Catholics, the Laetare Award. It is an annual award given by the University of Notre Dame in recognition of outstanding service to the Catholic Church and to society. Sister Bowman died in 1990. (Courtesy of Elmwood Cemetery Archives.)

John T. Fisher II was a former Marine who ran his family's successful Chrysler automobile dealership, where he once sold a car to Elvis Presley. His deep sense of public service grew after his experiences following the assassination of Dr. Martin Luther King Jr. in 1968. Fisher worked with civic and religious leaders of all races to help bring the community together. He later worked with the Council of World Churches in Geneva, Switzerland, where he helped divest the council's investments in businesses that supported South African apartheid. (Courtesy of Jean Fisher.)

After having worked his way up in the bond department at the First National Bank to manager and on, Allen B. Morgan Sr. eventually retired as the chairman of First Tennessee National Corp. He was a director of the Federal Reserve Memphis Branch in St. Louis and the Federal Reserve Advisory Council in Washington, DC. Banking was at the heart of his business life, but he was a philanthropist who inspired others to give deeply. (Courtesy of the Digital Archive of the Memphis Public Library & Information Center.)

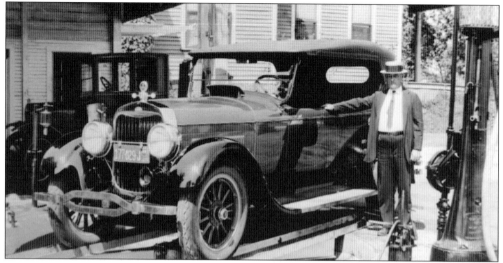

After his service in World War I, Peter Lunati opened a small garage. Inspiration struck, and he invented the first automotive hydraulic lift. Lunati patented what would become known as the Rotary Lift, and his company became the first division of Dover Corporation, which now trades under the symbol DOV on the New York Stock Exchange. Lunati eventually left the company, founded a church, and worked as an unpaid pastor for the remainder of his life. (Courtesy of the Rotary Lift Company.)

Patrons of a grand restaurant located at 919 Coward Place recall with fondness the food and the owner of the establishment, Justine Holdway Taylor Smith. Smith and her husband purchased the house in 1957 and renovated it for commercial purposes. The New Orleans–style French cuisine delighted her patrons, from Elvis Presley to Pres. Bill Clinton. The restaurant was in operation from 1958 until 1996. (Painting by Billy Price Carroll, courtesy of Janet Smith.)

James Taliaferro (pronounced "Toliver") "Tolly" Murff ran what was considered a medium-sized cotton business that he inherited from his father, Harvey Johnson Murff. Born in Clarksdale, Mississippi, he eventually joined the Clarksdale, Mississippi, branch and opened the Memphis branch of the H.J. Murff Cotton Company. Murff was widely regarded as a fair cotton trader who enjoyed friendships with his competitors. He was a member of the New York Cotton Exchange and was on the board of directors of the Union Planters National Bank, among other civic and business posts. He is seen here with his wife, Frances Smith Murff. (Courtesy of Preservation & Special Collections Department/University Libraries/University of Memphis.)

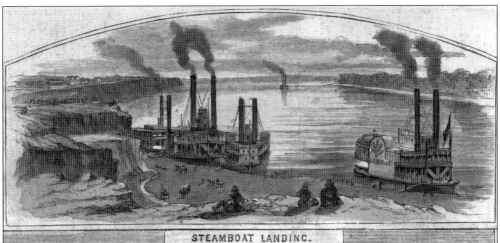

STEAMBOAT LANDING.

Capt. William "Billy" Ashford served as a "cub pilot" on the Mississippi River at the same time as Samuel Clemens. Ashford was originally from Carroll County, Tennessee, and ran away from home to live with relatives at 12 because he was afraid of his father's punishment for swimming in the Mississippi River. Perpetually drawn to the river, Ashford piloted the Mississippi and White Rivers while steamboating was at its peak. His son Gabe would later pilot steamboats as well. (Courtesy of American Memory Collection.)

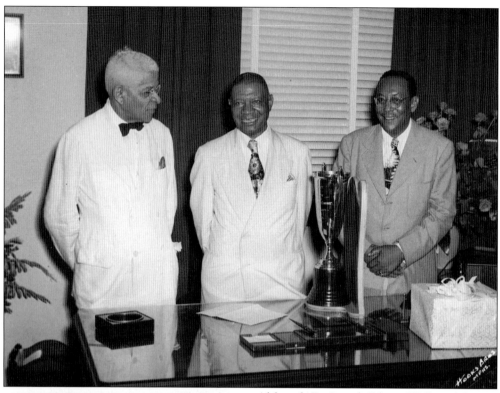

Although Dr. Joseph Edison Walker's life ended abruptly with his murder in 1958, his life was spent in service to the African American community of Memphis. He earned a medical degree in 1905, worked as a teacher and a doctor, and then started the Delta Penny Savings Bank and eventually headed the Mississippi Life Insurance Company. After moving to Memphis, Dr. Walker changed the landscape of insurance and banking for African Americans by founding the Universal Life Insurance Company and the Tri-State Bank. Dr. Walker is seen here at center. (Courtesy of the Digital Archive of the Memphis Public Library & Information Center.)

Dr. Walker was deeply involved in the local Negro Chamber of Commerce, the National Negro Business League, the Memphis Urban League, and the Memphis branch of the NAACP. He was deeply committed to his faith, helping start the Walker Memorial Christian Church and Riverview Christian Church. He is seen here with his wife, Lela. (Courtesy of the Digital Archive of the Memphis Public Library & Information Center.)

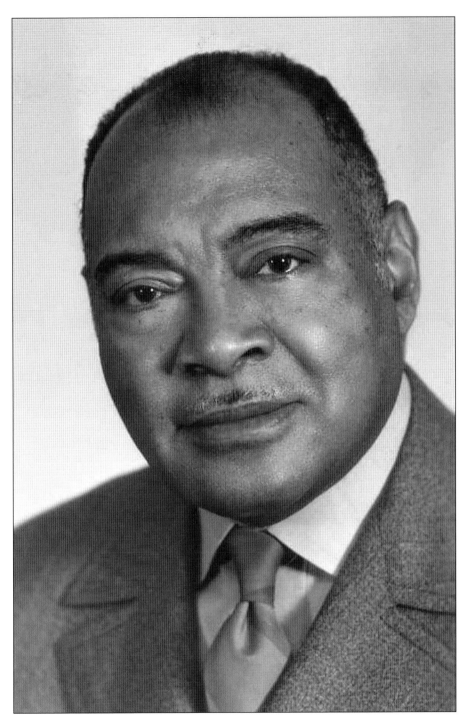

Dr. Joseph Edison Walker's son A. Maceo Walker followed in his footsteps. After years spent studying at Fisk, New York University, and the University of Michigan, Walker was the first to recommend the desegregation of the Memphis buses, and he helped to integrate the zoo, the library, an art museum, and later, the Memphis public school system. (Courtesy of the Digital Archive of the Memphis Public Library & Information Center.)

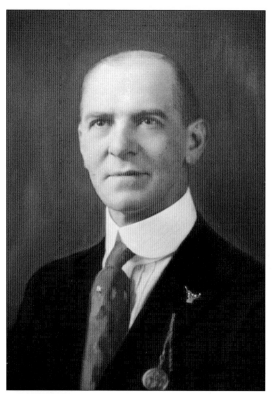

Charles Martin Dinstuhl Sr. began his work in the candy and ice-cream business in 1901, selling out of a downtown storefront located next door to the Theatorium, an operation he also managed. (Courtesy of the Dinstuhl family collection.)

Dinstuhl's Fine Candies has seen five generations in the family business, which has produced quality candy, chocolate, and other treats for over 100 years. While the business no longer has a downtown storefront, three locations can be found at the Shops of Laurelwood, Germantown Village Square, and the production center on Pleasant View Road. (Courtesy of the Dinstuhl family collection.)

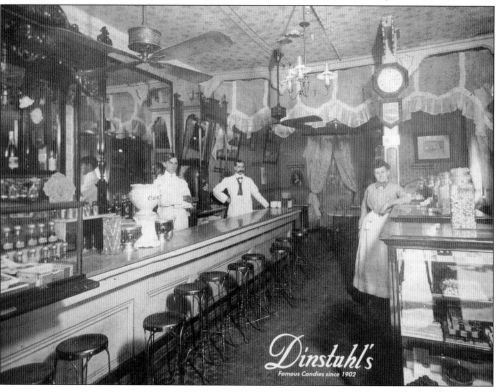

Five

AFRICAN AMERICAN INNOVATORS

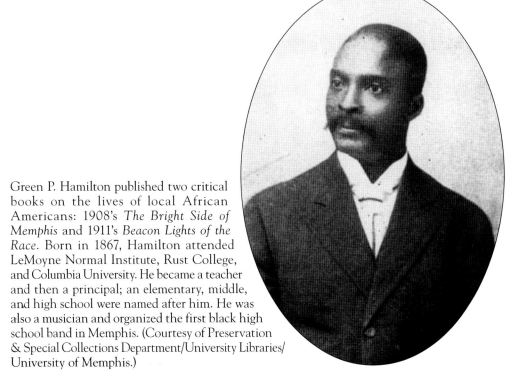

Green P. Hamilton published two critical books on the lives of local African Americans: 1908's *The Bright Side of Memphis* and 1911's *Beacon Lights of the Race*. Born in 1867, Hamilton attended LeMoyne Normal Institute, Rust College, and Columbia University. He became a teacher and then a principal; an elementary, middle, and high school were named after him. He was also a musician and organized the first black high school band in Memphis. (Courtesy of Preservation & Special Collections Department/University Libraries/ University of Memphis.)

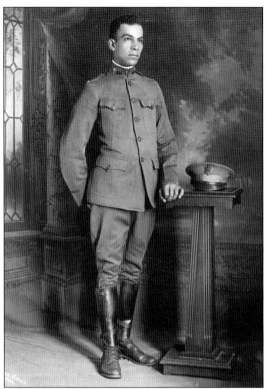

Blair T. Hunt was a minister, a community leader, a teacher, an educator, and an inspiration to the African American community of Memphis. He taught school and became a principal at the famous Booker T. Washington High School. A minister for 51 years at Mississippi Boulevard Christian Church, a veteran of World War I and active locally in the war effort of World War II, Hunt was the first African American to serve on both the Shelby County Schools Board of Education and the Tennessee draft board. (Courtesy of the Digital Archive of the Memphis Public Library & Information Center.)

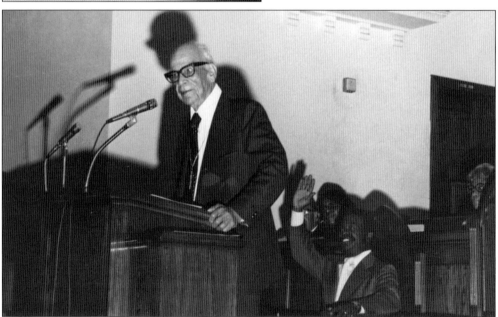

A section of the cemetery is named in Blair T. Hunt's memory. Blair's granddaughter Marsha was the inspiration behind the poster for the 1960s musical *Hair*. Marsha met Mick Jagger, and they had a child together. According to Marsha and Jagger biographer Christopher Sanford, Marsha is the woman for whom "Brown Sugar" was written. (Courtesy of the Digital Archive of the Memphis Public Library & Information Center.)

Born in Holly Springs, Mississippi, Robert Reed Church Sr. was self-educated and wildly successful. He was the child of Capt. Charles B. Church and Emmeline; Charles was a steamboat captain and Emmeline was an enslaved person who, it has been said, was the daughter of a Malaysian king. (Courtesy of Preservation & Special Collections Department/University Libraries/University of Memphis.)

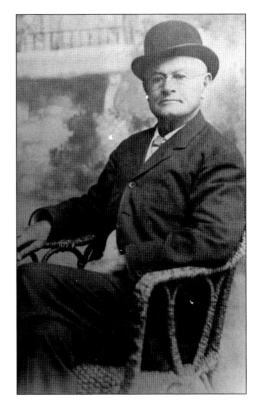

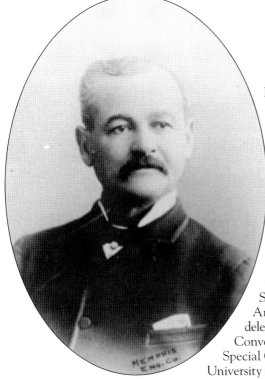

Robert Reed Church Sr.'s work life began around age 12 when he joined Captain Church on the packet boats the captain owned. He rose to the rank of steward, saved his money, and with the help of Memphis proprietor James Overton, opened a saloon at the corner of Second Street and Gayoso Avenue. During the 1878 yellow fever epidemic, land prices became so depressed and property so available that Robert purchased a great deal of property, amassing a sizable land bank. Church also bought the first city bond to reestablish Memphis as a city when the epidemic ended. He founded the Solvent Savings Bank & Trust in 1906, the first African American bank in Memphis. He served as a delegate from Memphis at the Republican National Convention in 1900. (Courtesy of Preservation & Special Collections Department/University Libraries/ University of Memphis.)

In 1899, Robert Reed Church Sr. donated land at the east end of Beale Street to the African American citizens of Memphis and opened Church Park and Auditorium. Pres. Theodore Roosevelt and Booker T. Washington were counted among the influential leaders who spoke to the public at the auditorium. Duke Ellington performed there, as did Cab Calloway, Louis Armstrong, and W.C. Handy. Robert Church Sr. is largely regarded as the South's first black millionaire. (Courtesy of Preservation & Special Collections Department/ University Libraries/ University of Memphis.)

Anna Wright Church, the second wife of Robert R. Church Sr., was educated at the LeMoyne Normal Institute, Antioch College, and the Oberlin Conservatory of Music. She married Robert Sr. on January 1, 1885. A well-known city school principal of Auction Street School and an accomplished musician, she was organist and choir directress of Emmanuel Church. Her abilities were such that she was invited to join Europe-bound ocean liners as a singer and pianist. (Courtesy of Preservation & Special Collections Department/University Libraries/University of Memphis.)

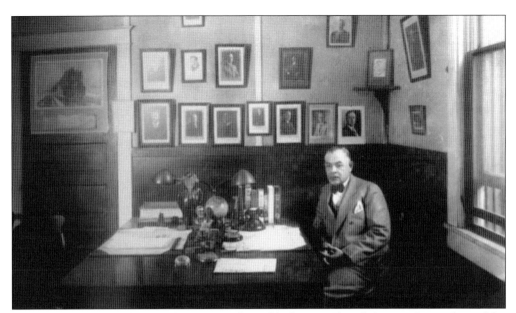

Robert R. Church Jr., the son of Anna Wright and Robert R. Church Sr., was first cashier of the Solvent Savings Bank & Trust and later, the bank's president. Early on, he spent time on Wall Street learning banking and then returned to Memphis. He founded and financed the city's Lincoln League and served as a delegate at eight Republican conventions. In 1917, he organized the state of Tennessee's first chapter of the NAACP at a meeting in Church Park. (Courtesy of Preservation & Special Collections Department/University Libraries/University of Memphis.)

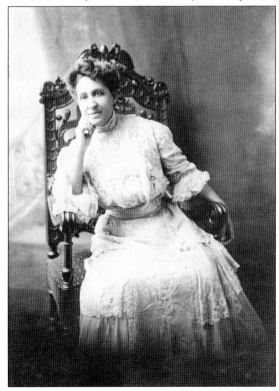

Mary Church Terrell, the daughter of Louisa and Robert R. Church Sr., was born in 1863, and was a contemporary of Ida B. Wells. Her father took a keen interest in her education and sent her to school at Oberlin College. Her life in Washington was spent teaching and advocating for women's rights. She spoke out for rights for African-Americans and even became the first president of the National Association for Colored Women and a charter member of the NAACP. (Courtesy of Preservation & Special Collections Department/University Libraries/University of Memphis.)

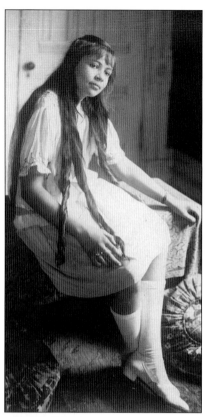

Sara Roberta Church, who went by Roberta, was the only daughter of Sara Johnson Church and Robert R. Church Jr. She earned undergraduate and graduate degrees from Northwestern University. She entered into the political sphere when her father died unexpectedly during an election he had entered; she took his place on the ballot and won the election. This election was groundbreaking in that it occurred before the passage of the Voting Rights Act or the push for equal rights for women. (Courtesy of Preservation & Special Collections Department/University Libraries/University of Memphis.)

Roberta Church served as the first black woman on the Republican State Executive Committee of Tennessee. In 1953, she served in the Eisenhower administration as a minority group consultant to promote equal employment opportunities. She also served in the Nixon administration and wrote two important books, one with coauthor Annette E. Church, her aunt, called *The Robert R. Churches of Memphis*, and another with friend Ronald Walter, called *Nineteenth Century Memphis Families of Color*. During her life, she donated a bronze bust of her grandfather to the citizens of Memphis. The bust can be seen in Church Park at 381 Beale Street. (Courtesy of Preservation & Special Collections Department/University Libraries/University of Memphis.)

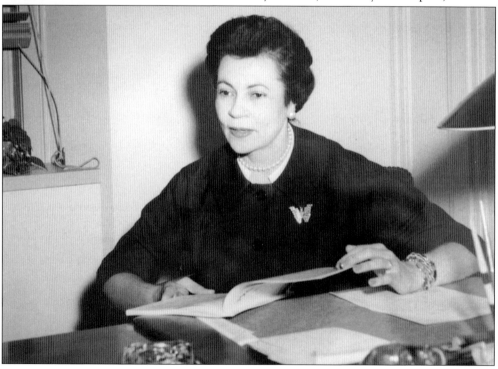

George Washington Lee, also known as "Lieutenant Lee," was a close friend of Robert Church Jr. and an active member of the Republican party. He was one of the first African American officers to serve in World War I. He was an insurance executive and a noted author who wrote *Beale Street: Where the Blues Began* in 1934. His reputation as a storyteller preceded him, and he was known as "the Sage of Beale Street." (Courtesy of the Digital Archive of the Memphis Public Library & Information Center.)

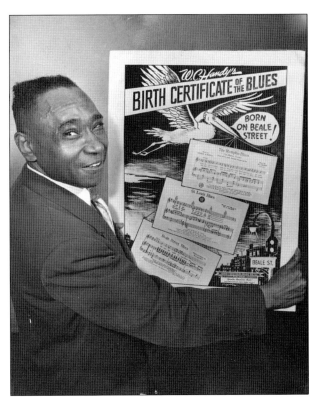

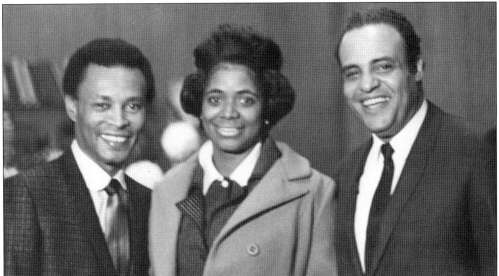

Archie Walter Willis Jr. (left) is pictured here with Carla Thomas and Rev. Dr. Benjamin Hooks. Willis was an attorney who represented James Meredith in the desegregation of the University of Mississippi. He was one of the attorneys who fought for the desegregation of the Memphis school system. He founded the first integrated law firm in the city of Memphis, and cofounded the only mortgage company owned by African Americans at the time. His descendants remain active on Elmwood's board of trustees. (Courtesy of the Digital Archive of the Memphis Public Library & Information Center.)

Judge Odell Horton Sr. attended Morehouse College, and while serving a second tour in the US Marine Corps, he attended the US Navy School of Journalism and then Howard University Law School. Horton became an assistant US attorney. In 1980 and for the next 17 years, Horton served in the US District Court for the Western District of Tennessee. He was appointed to this post by Pres. Jimmy Carter. (Courtesy of the Digital Archive of the Memphis Public Library & Information Center.)

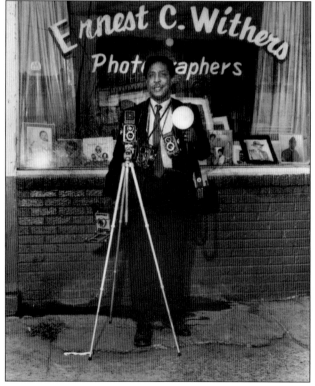

As a professional photographer, Ernest Withers traveled with Dr. Martin Luther King Jr., taking one of the most iconic photographs of the era, hundreds of striking Memphis sanitation workers holding signs reading, "I am a Man." He photographed the Emmett Till trial in the Mississippi Delta in 1955, bringing national attention to the brutalities of the segregated South. The Withers Collection Museum and Gallery is located at 333 Beale Street. (© Ernest C. Withers, courtesy of the Withers Family Trust.)

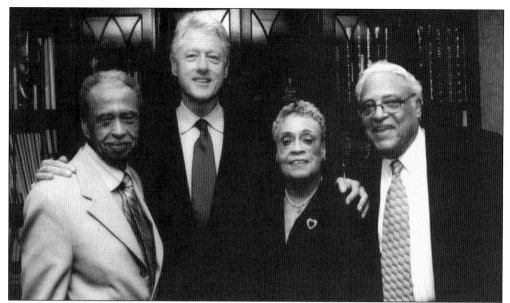

Vasco Smith Jr. (left) was a well-known dentist who attended Booker T. Washington High School, LeMoyne College, and Meharry Medical College. He was an Air Force veteran of both World War II and the Korean War and later became a Shelby County commissioner, serving from 1973 until 1994. The Shelby County Administration Building was named for him. He is pictured here with, from left to right, Pres. Bill Clinton, his wife Maxine, and Rev. Dr. Benjamin Hooks. (Courtesy of the Digital Archive of the Memphis Public Library & Information Center.)

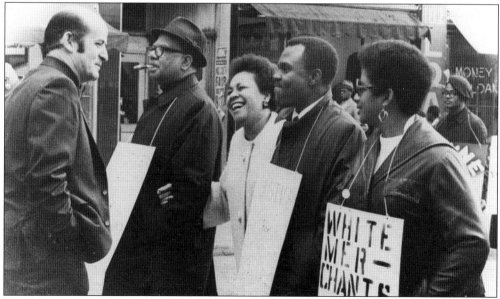

Maxine Smith's civil rights activism began in 1957 when she was denied admittance to Memphis State University because she was black. She went on to spend almost 25 years on the Memphis Board of Education. Smith took up the cause of the sanitation workers in their strike in 1968. She served as the executive secretary of the Memphis Branch of the NAACP from 1962 through 1995. In this photograph, she is the third from the left, marching on Beale Street. (Courtesy of the Digital Archive of the Memphis Public Library & Information Center.)

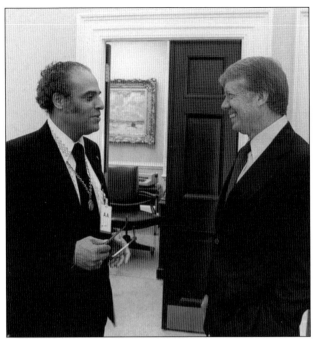

Rev. Dr. Hooks is known as the executive director of the NAACP, but he was also a pastor of Greater Middle Baptist Church in Memphis and a presidential appointee to the FCC. Hooks earned a law degree from DePaul University in 1948, attending the school in Chicago only because the State of Tennessee would not admit African American students to its law programs. The Memphis Public Library was renamed the Benjamin L. Hooks Library in 2001. His wife, Frances Hooks, passed away in late January 2016. Hooks is pictured here with former president Jimmy Carter. (Courtesy of the Digital Archive of the Memphis Public Library & Information Center.)

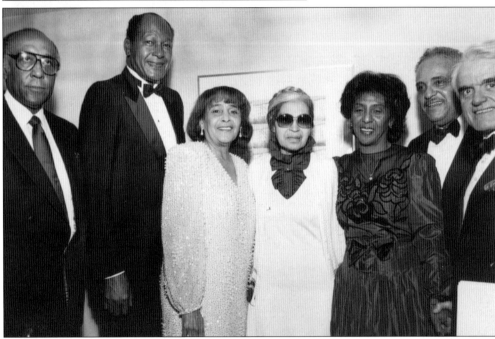

Frances Louise Dancy Hooks, who was widely known as the perfect complement to Rev. Dr. Hooks, was a civil rights activist in her own right. She cofounded Women in NAACP, a program within the NAACP that dealt with civil rights issues faced by women and children. Frances was a teacher for 24 years and cofounded a program that assisted African American students in applying for financial aid for college. She was one of the founders of the Women's Foundation of Greater Memphis. Civil rights leader Rosa Parks is in the center of this photograph, and Frances is to her right. (Courtesy of the Digital Archive of the Memphis Public Library & Information Center.)

Josiah Settle was the child of a white slave owner and an enslaved woman. Settle received a law degree from Howard. After his move to Memphis, he was appointed assistant attorney general in the Shelby County Criminal Court and was the attorney for the Solvent Savings Bank & Trust. He and attorney Benjamin Booth were early challengers of Jim Crow–era segregation laws that they argued before the state supreme court. (Courtesy of the Digital Archive of the Memphis Public Library & Information Center.)

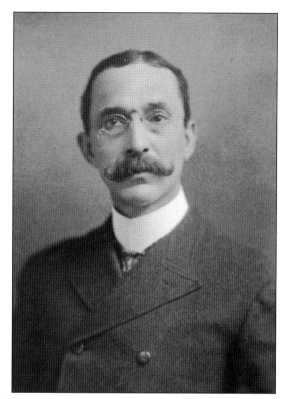

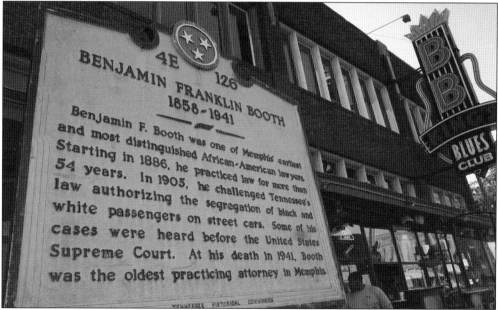

Benjamin Franklin Booth, born to slaves in Prentiss County, Mississippi, became one of the most important attorneys in Memphis. With the help of Col. William Inge, the speaker of the Mississippi House, Booth was admitted to the bar. With Josiah Settle, Booth argued the case of Mary Morrison against Jim Crow–era segregation on Memphis streetcars in front of the Tennessee Supreme Court. His historical marker stands on Beale Street. (Photograph by Willy Bearden.)

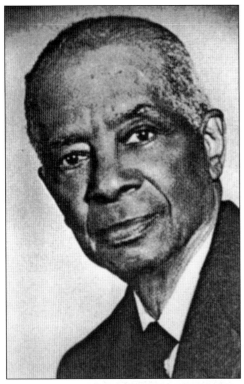

R.S. Lewis and Sons Funeral Home was opened in Memphis in 1914 and remains in business today. Lewis owned the Memphis Red Sox of the Negro Baseball League and built the first baseball stadium in the country owned by an African American. Lewis Stadium was later sold to the Martin brothers and renamed Martin Stadium. After Martin Luther King Jr. was assassinated on April 4, 1968, his body was embalmed at R.S. Lewis and Sons. (Courtesy of Elmwood Cemetery Archives.)

The oldest African American business in Memphis was once the T.H. Hayes & Sons Funeral Home. It was owned and operated by the Hayes family, pictured here from left to right: Thomas Jr., Florence, Thomas Sr., and Taylor. Thomas Sr. opened the business in 1902 on Poplar Avenue but relocated it to South Lauderdale in 1918. Son Thomas Jr. owned the Birmingham Black Barons, a Negro League baseball team that once had Willie Mays as a player. (Courtesy of the Digital Archive of the Memphis Public Library & Information Center.)

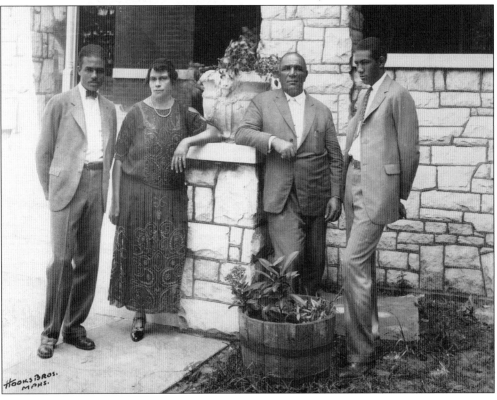

Six

MEDICINE AND MEMPHIS

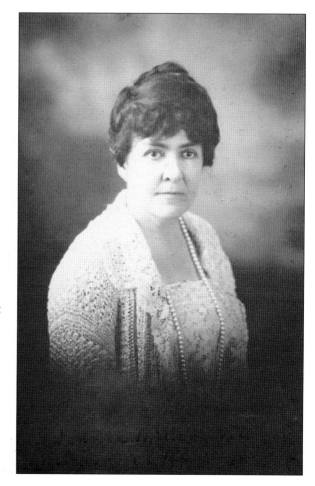

As a young woman and despite being crippled by polio at an early age, Dr. Janet Miller worked for most of her adult life as a missionary in the Philippines, Japan, and China. She earned medical degrees from the University of Japan and Oxford University and practiced medicine during her missions. She wrote two books, *Jungles Preferred* and *Camel Bells of Bagdad*. Her name appeared on the 1915 nomination roster for the Nobel Peace Prize. (Courtesy of Mary Ann Traylor.)

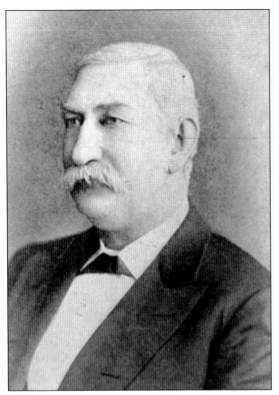

Dr. D.T. Porter was the president of what was formerly the city of Memphis but would become the taxing district of Shelby County in 1879, one year after the worst yellow fever epidemic in Memphis history. Dr. Porter's efforts to improve sanitation have been credited with rebuilding the city from its darkest hour. (Courtesy of the Digital Archive of the Memphis Public Library & Information Center.)

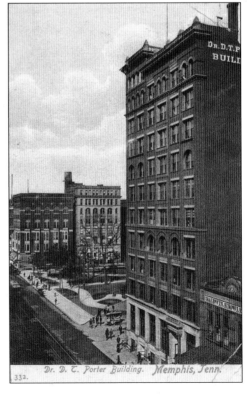

The Porter Building in downtown Memphis was the first in the city to have an elevator; this modern convenience was available to the public for rides, for which they paid 10¢. For many years, it was the tallest skyscraper south of St. Louis. (Courtesy of the Digital Archive of the Memphis Public Library & Information Center.)

Chief Charles B. "Kippy Kio" Harris is among the most unique Elmwood residents. Not only was he of Native American heritage, he was a chief and also an herb doctor. He operated a drugstore on Polk Avenue called Griffin Drug Store. Chief Kippy Kio was born in 1832 and died in 1943, making him, at age 111, one of the oldest people to be buried at Elmwood. (Courtesy of Kristy Carter.)

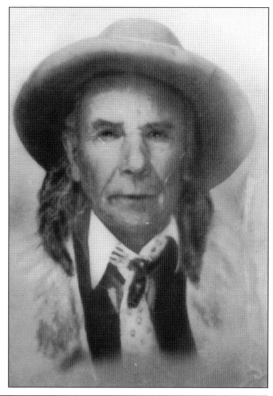

Dr. Willis Campbell literally wrote the book on orthopedics. Campbell's *Operative Orthopaedics*, now in its 11th edition, is the largest selling orthopedic textbook in the world and is published in seven different languages. Campbell Clinic is recognized as one of the premier orthopedic practices in the country. Dr. Campbell is in the center of this photograph. (Courtesy of Elmwood Cemetery Archives.)

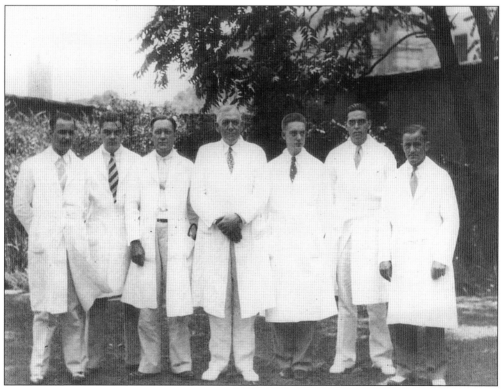

Before major league baseball was integrated, the Negro Leagues flourished in cities and towns throughout the South. Memphis was no exception. The Martin brothers were all doctors who owned the Memphis Red Sox. Dr. William S. Martin graduated from Meharry Medical College and opened his practice in Memphis in 1907. Another brother, Dr. B.B. Martin, was trained as a dentist and owned a building on South Third Street. Dr. A.T. Martin practiced medicine in Memphis for over 50 years, and Dr. J.B. Martin was a pharmacist. In 1927, the brothers bought the Red Sox and the baseball stadium, which they renamed Martin Stadium. Over the years, many outstanding players were part of the Martin brothers' organization, including John "Buck" O'Neil, Verdell "Lefty" Mathis, and Frank "Wahoo" Pearson. (Courtesy of Elmwood Cemetery Archives.)

Dr. George Oral Waring III, a surgeon and ophthalmologist, was awarded a National Institutes of Health Fogarty International Scholars Award to study laser corneal surgery in Paris. While there, Dr. Waring served as chairman of the ophthalmology department and then as director of research at Al-Magrabi Eye Hospital in Saudi Arabia; it was here that he helped to develop LASIK surgery. (Courtesy of Dr. Dennis Waring.)

Seven

ACTIVISTS AND POLITICIANS

Thomas Battle Turley is one of two US senators buried at Elmwood. He was an attorney who filled the unexpired Senate seat of his law practice associate, Isham Harris. He declined to run again, preferring instead to focus on the law and his practice. His descendants remain active on Elmwood's board of trustees. Elmwood is divided into sections, which are named for various families; the Turley section is the largest section at Elmwood. (Courtesy of American Memory Collection.)

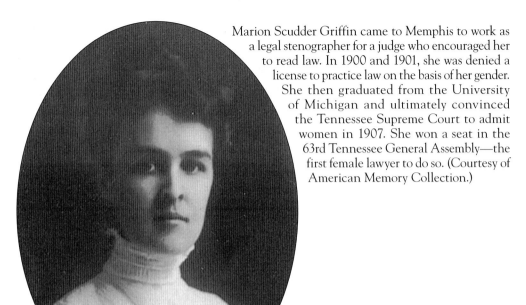

Marion Scudder Griffin came to Memphis to work as a legal stenographer for a judge who encouraged her to read law. In 1900 and 1901, she was denied a license to practice law on the basis of her gender. She then graduated from the University of Michigan and ultimately convinced the Tennessee Supreme Court to admit women in 1907. She won a seat in the 63rd Tennessee General Assembly—the first female lawyer to do so. (Courtesy of American Memory Collection.)

He served in both the state senate and the US House before he was elected governor of Tennessee in 1857. Isham Green Harris was the person responsible for steering the state of Tennessee into the Civil War and the Confederacy. In 1861, when Abraham Lincoln called for soldiers from Tennessee for the purpose of defending the Union, it was Harris who denied the president. He turned the state government over to the Confederate army and then fled to Memphis, where the legislature tried to meet, and did, until Federal troops advanced. Harris joined the Confederate army, ended up a wanted man after the war, spent time in Mexico and London, and was then allowed to return to Memphis in 1867. He practiced law but returned to politics as a US senator. (Courtesy of American Memory Collection.)

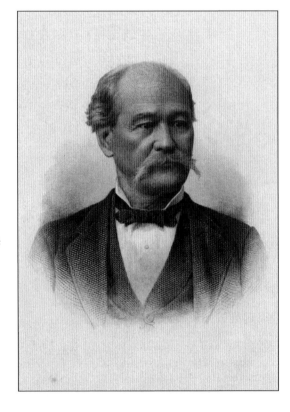

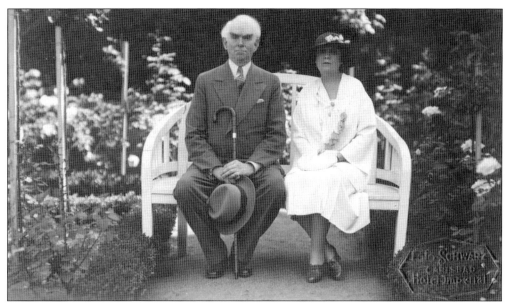

No single person wielded more influence on the city of Memphis than Edward Hull Crump, who is pictured here with his wife, Bessie Byrd McLean. He was the "Boss" (his nickname) for almost 50 years, as his personality and beliefs molded public policy far beyond the borders of the city. He served as mayor of Memphis from 1910 to 1915; US congressman from 1931 to 1935; Shelby County treasurer, fire, and police commissioner; and a Democratic party delegate seven times. (Courtesy of the Digital Archive of the Memphis Public Library & Information Center.)

Crump built a powerful political machine that included black voters, hand-picked candidates for every office on the ballot, and block captains to keep everyone in line. Although he passed away in 1954, Crump's influence resonates to this day in ways small and large in Memphis. (Courtesy of the Digital Archive of the Memphis Public Library & Information Center.)

Edmund Orgill was considered a progressive in the area of civil rights. He was a businessman who became interested in politics in the late 1940s, and was one of a group of concerned citizens who campaigned against the Crump political machine. He became mayor in 1956, and ran unsuccessfully for governor in 1958. He also served on the Shelby County Quarterly Court from 1966 through 1972. (Courtesy of the Digital Archive of the Memphis Public Library & Information Center.)

Known to her constituents as one of the longest serving female lawmakers in the United States, Tennessee representative Lois DeBerry-Traughber was the longest serving female member of the state House of Representatives, as well as the first female speaker pro tempore in the House and the second African American woman to serve in the Tennessee General Assembly. DeBerry-Traughber gave the nominating speech for Vice Pres. Al Gore at the Democratic National Convention in 2000. (Courtesy of Elmwood Cemetery Archives.)

At his death, Kenneth McKellar held the distinction of being the longest serving senator in US history. Elected to the US House of Representatives in 1911, he served until 1917, when he was elected to the Senate, where he served until 1953. McKellar was an ally of Memphis political boss E.H. Crump. During the Roosevelt administration, McKellar used his seniority to help his state benefit from New Deal programs such as the TVA and federal aid to farmers. (Courtesy of American Memory Collection.)

After Franklin Roosevelt died in 1945, McKellar was president pro tem of the Senate, and served as acting vice president when Harry S. Truman rose to the presidency. He was defeated in the race for his seventh term in the Senate by Albert Gore Sr. (Courtesy of American Memory Collection.)

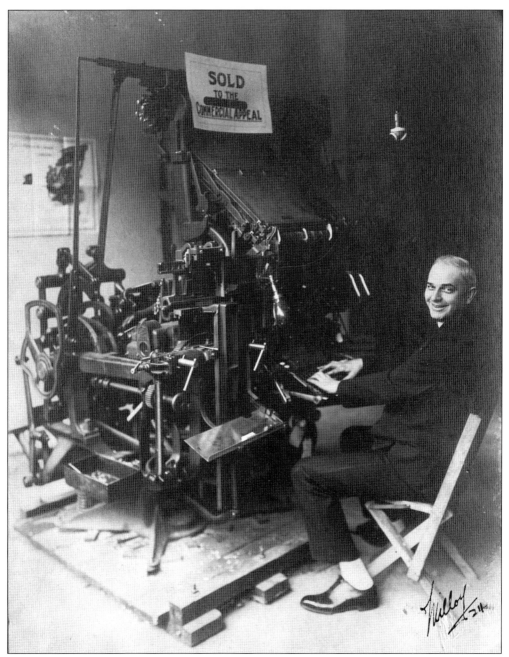

Rowlett Paine was elected Memphis mayor in 1920. Mayor Paine was against the KKK and ran in direct opposition to its politics; the group then burned a cross in his yard. Mayor Paine was also said to be one of the handsomest men in Memphis, and he credited the newly franchised woman vote with his successful election. He was committed to public health issues and worked to build the Harrahan Bridge. Paine left office in 1928. (Courtesy of the Digital Archive of the Memphis Public Library & Information Center.)

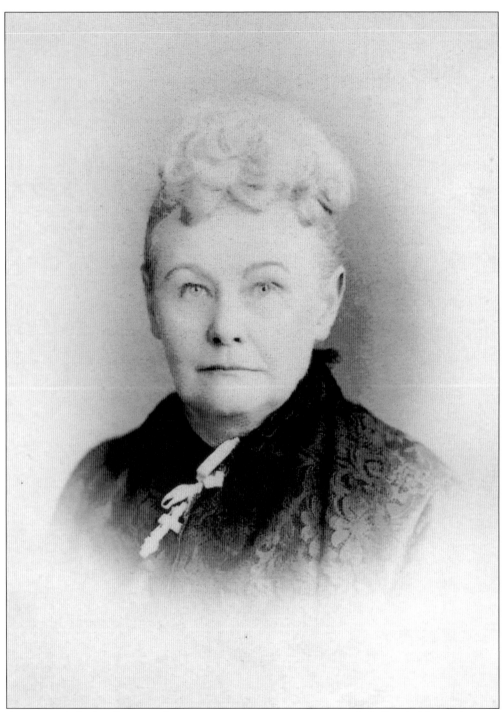

An accomplished suffragist and a temperance movement organizer, Lide Smith Meriwether was an early supporter of equal rights for women. In 1872, she published a book called *Soundings*, which focused on the problems faced by prostitutes. She worked to organize women of all races under the temperance cause. She was the first and ultimately "president for life" of the Tennessee Equal Rights Association. (Courtesy of Meriwether Archives.)

Eight

THE CIVIL WAR

The monument to the Confederate dead was purchased after $5,000 was raised by the Ladies Memorial Association and the Confederate Relief and Historical Association. The monument was unveiled in June 1878. It is inscribed "Illis Victoriam Non Immortalitatem Fata Negaverunt," which translates from Latin to "the fates which refused them victory did not deny them immortality." Confederate Rest at Elmwood is one of the most visited places in the cemetery. More than 1,000 soldiers who fought for the Confederacy rest on this lot. The land for the burial of soldiers was set aside by the cemetery founders when Elmwood was established. (Photograph by Willy Bearden.)

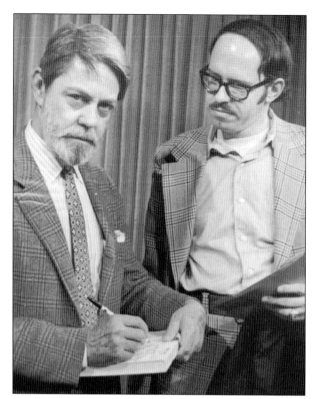

Shelby Foote was a historian, novelist, and surprisingly, the star of the most watched PBS series of all time, Ken Burns's *The Civil War*. Foote wrote six novels but is best known for his three-volume, 3,000-page opus, *The Civil War: A Narrative*, which he began writing in 1954 and finished in 1974. (Courtesy of the Digital Archive of the Memphis Public Library & Information Center.)

Although smuggling contraband through Union lines during the Civil War was considered treason, Isabella Buchanan "Belle" Edmondson's diary chronicles her many forays and exploits during the enemy occupation after the fall of Memphis in 1862. After a warrant for her arrest was issued, Belle sat out the remainder of the war on a plantation in Clay County, Mississippi. She returned to Memphis after the war and died unexpectedly in 1873. (Courtesy of the Digital Archive of the Memphis Public Library & Information Center.)

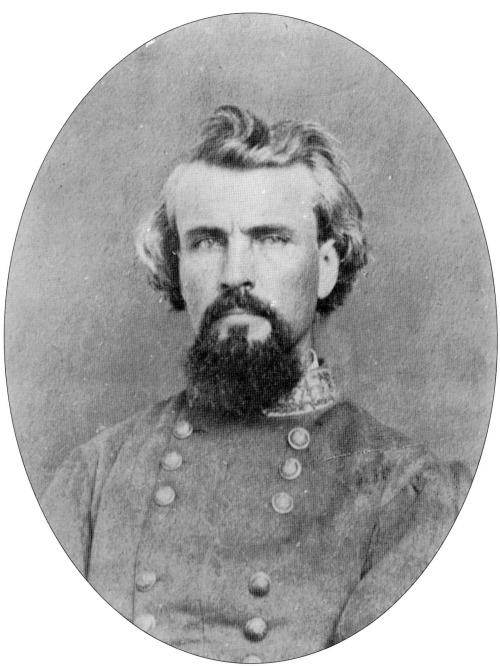

Civil War historian Shelby Foote claimed that there were two geniuses to come out of the Civil War: Abraham Lincoln and Nathan Bedford Forrest. Forrest was born in Bedford County, Tennessee. After his father's death, Forrest, at age 17, became the head of a large family, which he supported successfully as a planter and slave trader. Forrest was a lieutenant general in the Confederate army during the Civil War and is known as a skilled tactician among Civil War historians. His use of guerrilla warfare tactics is studied to this day in military colleges. He was the first grand wizard of the Ku Klux Klan, an organization from which he later distanced himself. (Courtesy of American Memory Collection.)

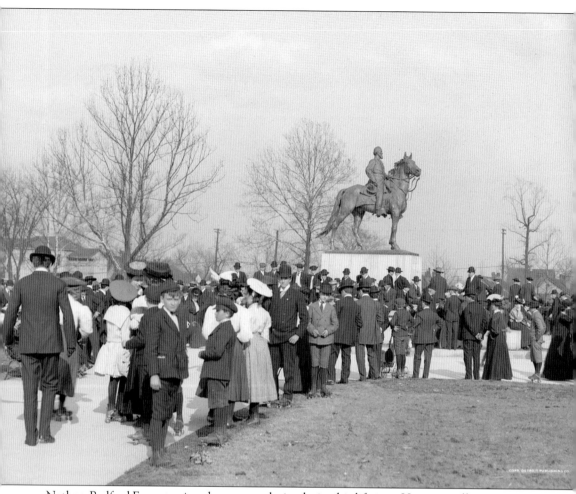

Nathan Bedford Forrest enjoyed great popularity during his lifetime. He eventually ran a prison work farm on President's Island in Memphis. He died in 1877 and was buried at Elmwood Cemetery in a family lot. In 1904, he and his wife, Mary, were removed from the cemetery and relocated to Forrest Park in downtown Memphis, where they rest to this day amid some controversy. A great bronze equestrian statue was commissioned and installed on the graves at the park. Many of the Forrest family members are still buried at Elmwood. (Courtesy of American Memory Collection.)

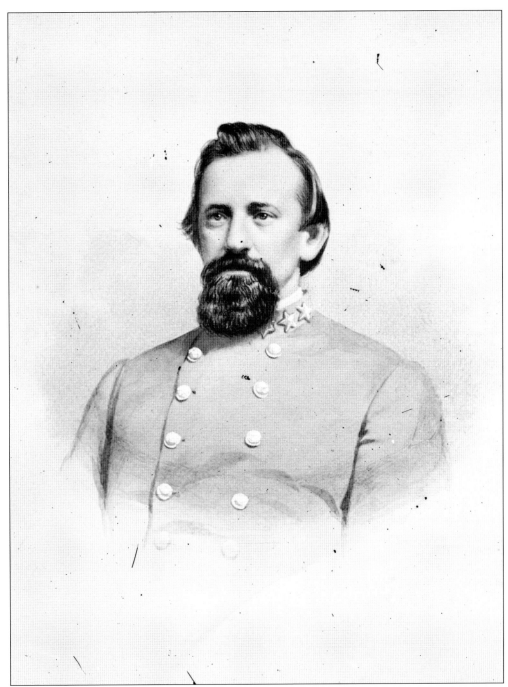

Gen. Alfred Jefferson Vaughn was initially opposed to secession but raised a company of men soon after Virginia and Mississippi left the Union. He served in the 13th Regiment of the Tennessee Infantry and fought at Shiloh, Belmont, Richmond, and Lookout Mountain. During these battles, he had eight horses shot out from under him but was not wounded until July 4, 1864, when he lost his leg in a battle near Marietta, Georgia. (Courtesy of American Memory Collection.)

William J. Smith is one of two men who served as generals for the United States during the Civil War to be buried at Elmwood. He served in the Mexican War, and then served in the Union Army from 1861 to 1865. He was a delegate to the tumultuous State Constitutional Convention after the Civil War. Smith is also known for having served as vice president of the Howard Association during the 1878 yellow fever epidemic. (Photograph by Willy Bearden.)

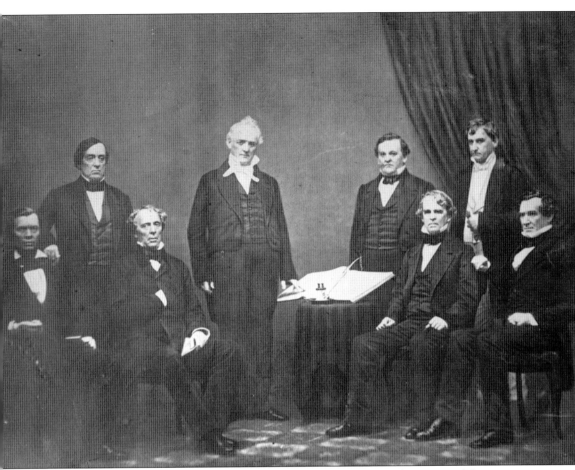

Jacob Thompson was a lawyer and a US representative and was appointed secretary of the interior in 1857 by Pres. James Buchanan. He is seen here at far left; President Buchanan is at center. Thompson resigned his post when the South seceded and became an aide to Gen. P.G.T. Beauregard. He served as a Confederate agent in Canada and was given the task of disrupting the banking system of the Northern states. He was accused of participating in the plot to assassinate Lincoln after the war, so he escaped to Europe with his wife, Catherine, whom he fell in love with years before when she was 13. When she turned 20, he sent her to finishing school in France so that she could be received in Washington as a lady. (Courtesy of American Memory Collection.)

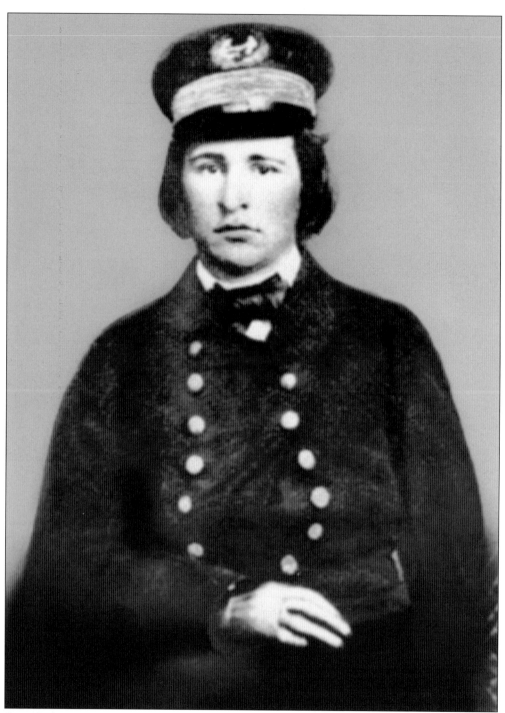

Capt. Dabney Minor Scales joined the Confederate Navy, won a Confederate Medal of Honor, and was assigned to the CSS *Shenandoah*. Captain Scales and fellow officers sailed to Europe, seeking support for the Confederates. His ship was the last to fire in the name of the Confederate cause, but only because the war ended two months before they received word of it. (Courtesy of Elmwood Cemetery Archives.)

120

Virginia "Ginny" Bethel Moon was born in 1844 and was 17 the year the Civil War erupted. The Battle of Memphis took place quickly one morning in June 1862. Memphis fell and became a hotbed of espionage for both the Union army and the Confederates. Ginny was attending school in Ohio at the war's onset and demanded to her mother that she be sent home. When her mother refused, Ginny reportedly borrowed a firearm and shot the stars out of the flag flying in the school's yard. Back in Memphis, Ginny transported quinine, morphine, and laudanum hidden in her voluminous skirts through the checkpoints held by Federal troops to her beloved Confederate soldiers. This sketch depicts a Southern belle in a dress that was likely as voluminous as Ginny's would have needed to be in order to hide so many supplies. Later in her life, she moved to Hollywood and appeared in two movies: *The Spanish Dancer* and *Robin Hood*. (Courtesy of *Harper's Weekly*.)

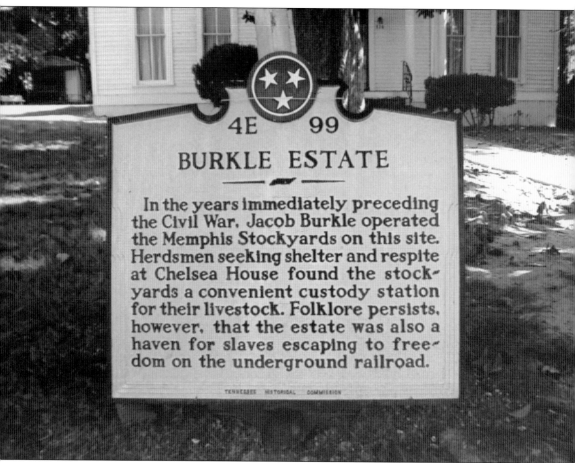

4E 99

BURKLE ESTATE

In the years immediately preceding the Civil War, Jacob Burkle operated the Memphis Stockyards on this site. Herdsmen seeking shelter and respite at Chelsea House found the stockyards a convenient custody station for their livestock. Folklore persists, however, that the estate was also a haven for slaves escaping to freedom on the underground railroad.

TENNESSEE HISTORICAL COMMISSION

A German immigrant, Jacob Burkle came to Memphis in the mid-1800s in an effort to escape conscription into Otto von Bismarck's army. Owner of a stockyard and bakery, Burkle's home, now known as the Burkle Estate, is considered to have been a stop on the Underground Railroad. The house was built in 1849. (Courtesy of the Digital Archive of the Memphis Public Library & Information Center.)

Nine

THE HOME OF THE BRAVE

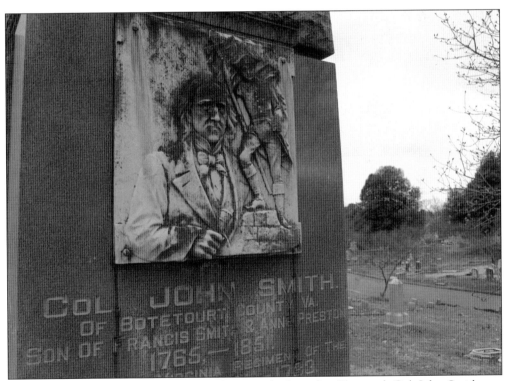

The only veteran of the American Revolution to be buried at Elmwood, Col. John Smith was not originally buried in the cemetery. Smith was visiting daughter Annie in Memphis when he died on June 16, 1851, at the age of 90. Buried in the Winchester Cemetery, Colonel Smith was disinterred and moved to Elmwood in 1894, and daughter Annie erected the family monument. John's wife's sister married the governor of Kentucky, Isaac Shelby, the man for whom Shelby County, Tennessee, is named. (Photograph by Willy Bearden.)

Brig. Gen. Luke William Finlay, a top graduate of West Point, served in the Corps of Engineers. He graduated from Yale Law School and was hired by a law firm in New York as the assistant to John W. Davis, the man who would oppose Calvin Coolidge in the presidential election of 1926. Finlay advised Pres. Harry Truman on labor policy, was given the diplomatic rank of minister for his work on the Marshall Plan, and was instrumental in forming NATO. (Courtesy of Elmwood Cemetery Archives.)

Photograph of bearer

Nellie Cockrell.

This passport is good for travel in all countries unless otherwise limited. This passport is valid for two years from the date of issue unless limited to a shorter period.

Valid only for
SPECIAL PILGRIMAGE
authorized under Act of
March 2, 1929.

At the end of World War I, many soldiers remained permanently buried overseas. After fighting with the government for over a decade, the mothers and widows of the fallen received funds to visit the gravesites from Congress and President Coolidge. These women were eventually known as the Gold Star Mothers. The name came from the gold star displayed on a black cloth mourning armband when a soldier was killed. Mary Ellen Murphy Cockrell, known as "Nellie," would make the trip to visit the gravesite of her son, Private Frank Cockrell, located in the Meuse-Argonne American Cemetery in Romagne-sous-Monfaucon, France. Private First Class Cockerel remains buried overseas to this day, and Nellie rests at Elmwood. (Courtesy of Elmwood Cemetery Archives.)

Staff Sergeant J. Bayard Snowden Jr. is not buried at Elmwood, but his cousin is. Snowden Jr. was killed at the Battle of the Bulge in 1945 and is buried in Luxemborg at a military cemetery. (Courtesy of Bayard Snowden.)

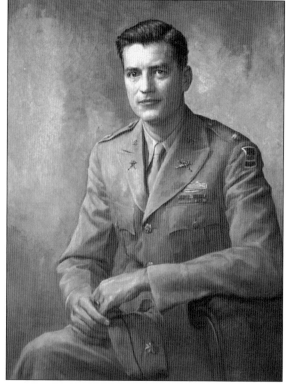

The life-sized bronze angel on the Snowden lot was installed by Sara Day Snowden for her son, Lt. Col. John B. Snowden II, commanded the 318th Infantry Battalion of the 3rd Army. He was killed in France in 1944, a year before his cousin, and was buried in a military cemetery overseas. His body was eventually returned to the United States and buried in Elmwood. (Courtesy of J. Bayard Snowden III.)

Marlin "Pee Wee" Carter served in the Coast Guard in World War II, but he also had a fantastic career in the Negro Leagues. He played third base for teams in Baltimore, Cincinnati, Chicago, Rochester, and San Antonio before landing on the Memphis Red Sox. Carter played for 19 seasons and was proclaimed the most versatile and valuable infielder. He was named to the East-West All Star Squad in 1942. (Courtesy of Elmwood Cemetery Archives.)

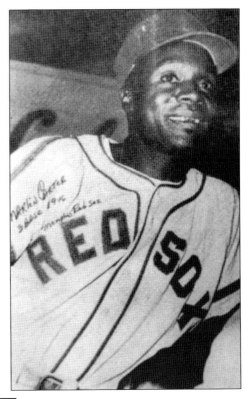

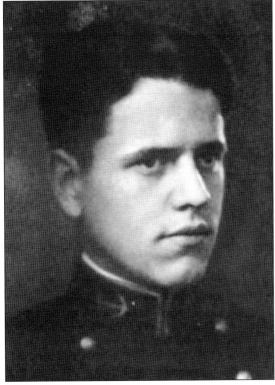

One of the great historic homes located in Memphis is closely tied to Elmwood resident Rear Adm. George R. Phelan. He served during the Sino-Japanese War and World War II, commanding destroyers in the Pacific Theater, and later became the chief of Navy Intelligence. Built in 1830, the Hunt Phelan Home is listed in the National Register of Historic Places and housed seven generations of Phelan's family. (Courtesy of American Memory Collection.)

DISCOVER THOUSANDS OF LOCAL HISTORY BOOKS FEATURING MILLIONS OF VINTAGE IMAGES

Arcadia Publishing, the leading local history publisher in the United States, is committed to making history accessible and meaningful through publishing books that celebrate and preserve the heritage of America's people and places.

Find more books like this at
www.arcadiapublishing.com

Search for your hometown history, your old stomping grounds, and even your favorite sports team.

Consistent with our mission to preserve history on a local level, this book was printed in South Carolina on American-made paper and manufactured entirely in the United States. Products carrying the accredited Forest Stewardship Council (FSC) label are printed on 100 percent FSC-certified paper.

MADE IN THE
USA